Happy
Birthday
Dad

Love,

Jack
7-31-2008

Sometimes Love is just
a frozen moment in time.

SEASONS

OF THE

ARCTIC

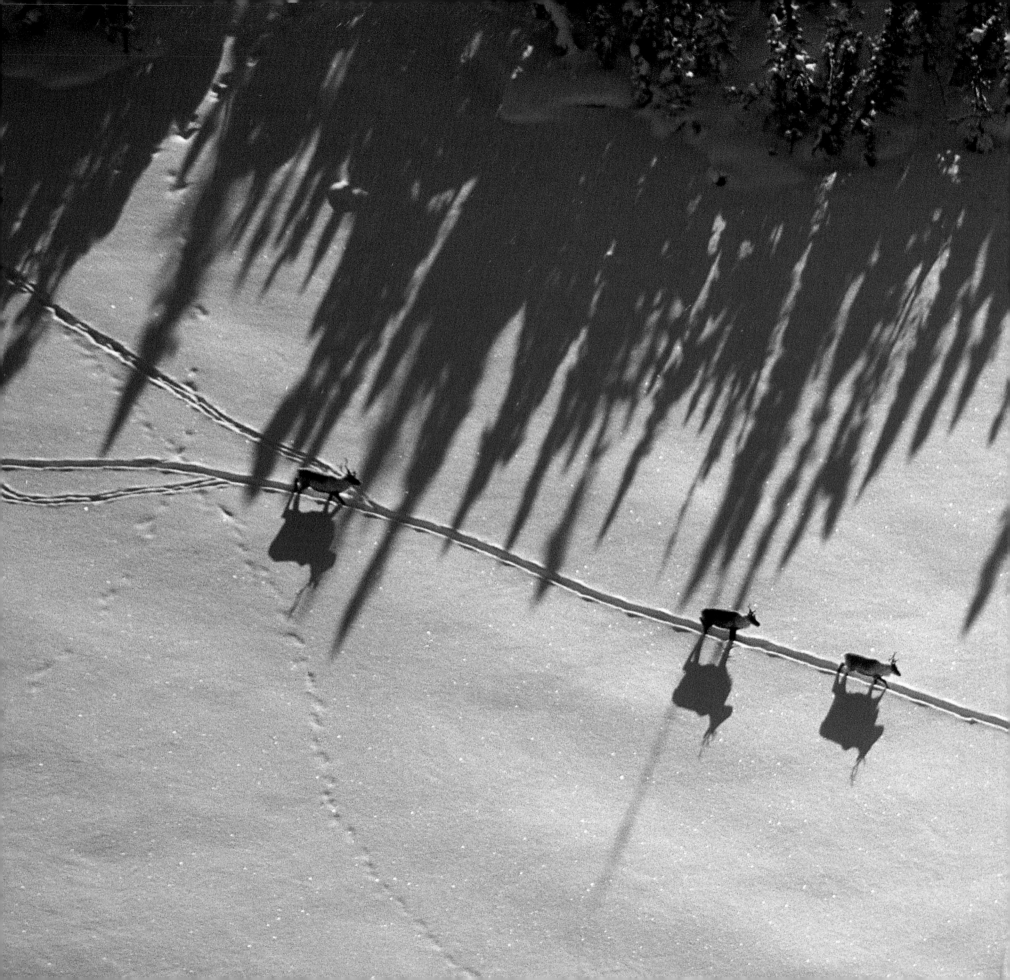

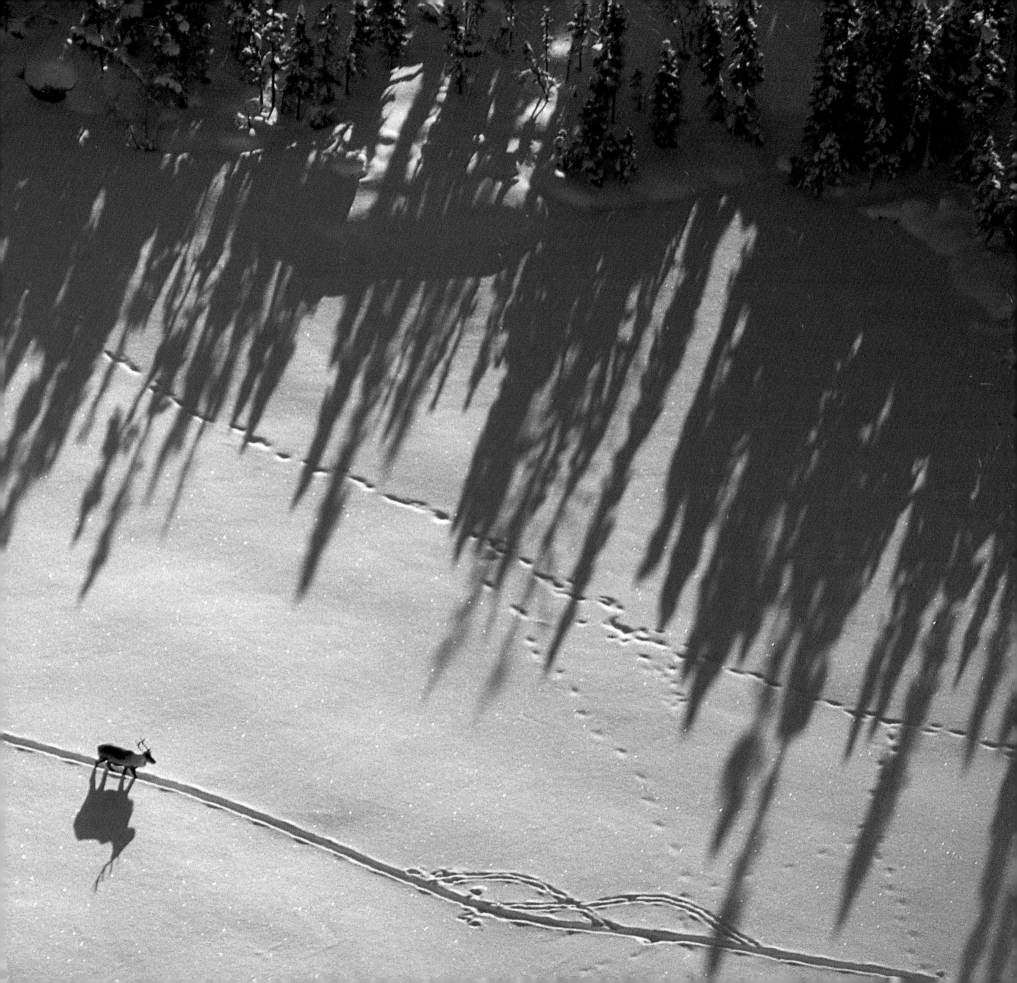

SEASONS OF THE
ARCTIC

PHOTOGRAPHS BY
Paul Nicklen

TEXT BY
Hugh Brody

SIERRA CLUB BOOKS

San Francisco

The Sierra Club, founded in 1892 by John Muir, has devoted itself to the study and protection of the earth's scenic and ecological resources—mountains, wetlands, woodlands, wild shores and rivers, deserts and plains. The publishing program of the Sierra Club offers books to the public as a nonprofit educational service in the hope that they may enlarge the public's understanding of the Club's basic concerns. The point of view expressed in each book, however, does not necessarily represent that of the Club. The Sierra Club has some sixty chapters coast to coast, in Canada, Hawaii, and Alaska. For information about how you may participate in its programs to preserve wilderness and the quality of life, please address inquiries to Sierra Club, 85 Second Street, San Francisco, CA 94105.

www.sierraclub.org/books

Photographs copyright © 2000 by Paul Nicklen
Text copyright © 2000 by Hugh Brody

Published by Sierra Club Books, in conjunction with Random House, Inc.

Originated and published in Canada by Greystone Books, a division of Douglas & McIntyre Ltd.

Library of Congress Cataloging-in-Publication Data is available from Sierra Club Books, 85 Second Street, San Francisco, CA 94105

Book and jacket design by Val Speidel
Map by Dean Cluff and Val Speidel
Printed and bound in Hong Kong

SIERRA CLUB, SIERRA CLUB BOOKS, and the Sierra Club design logos are registered tradmarks of the Sierra Club.

10 9 8 7 6 5 4 3 2 1

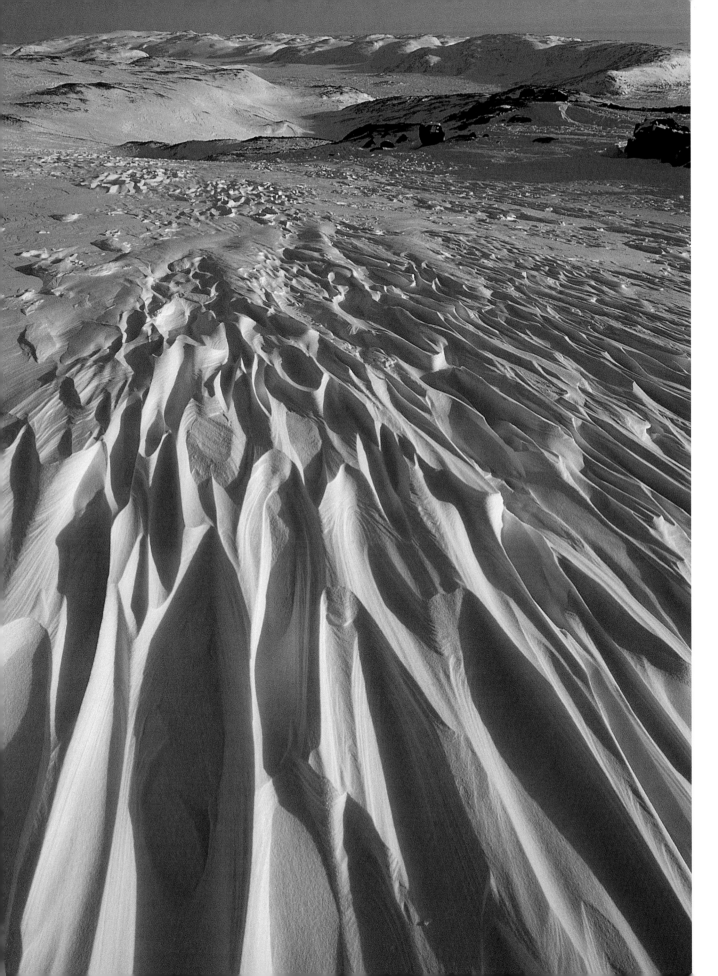

TO THOSE WHO STUDY

AND PRESERVE OUR

DELICATE NATURAL

RESOURCES, AND TO MY

FAVORITE NATURALIST

OF ALL, MY SOULMATE,

LYN HARTLEY

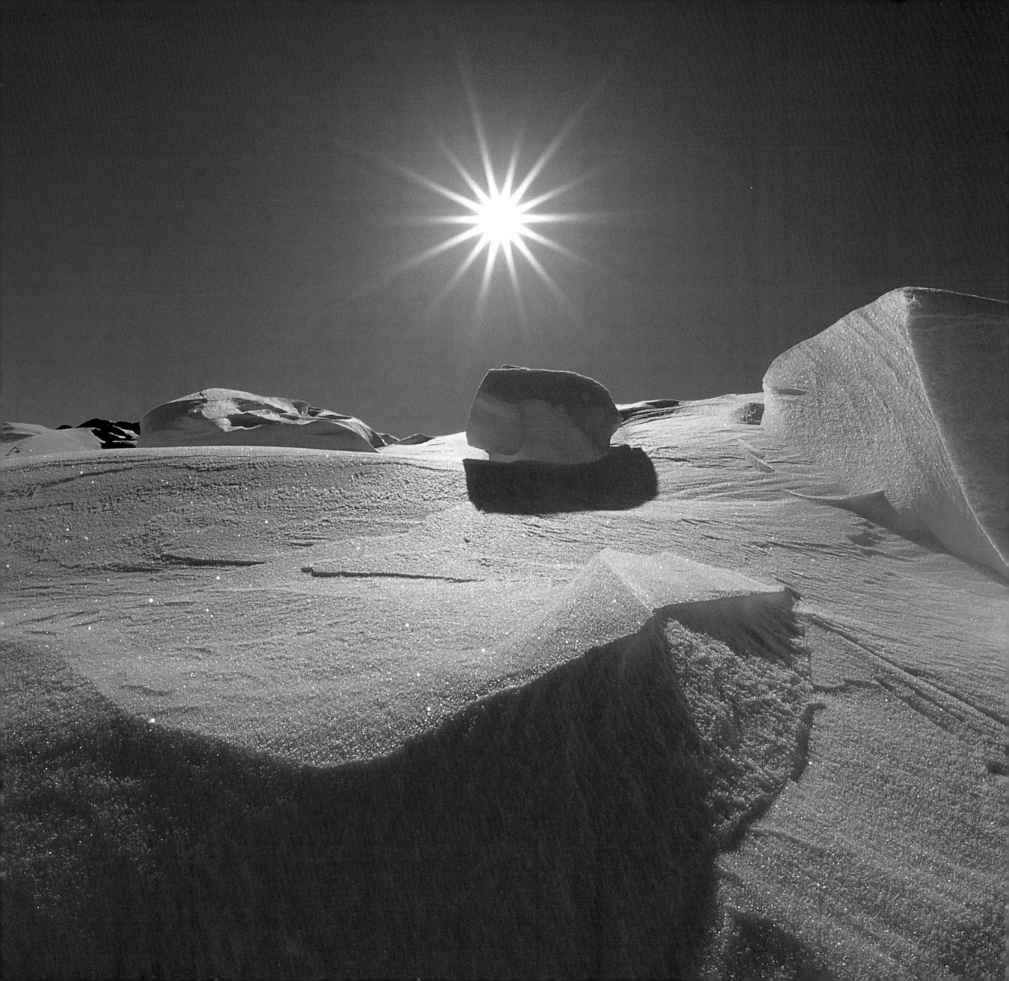

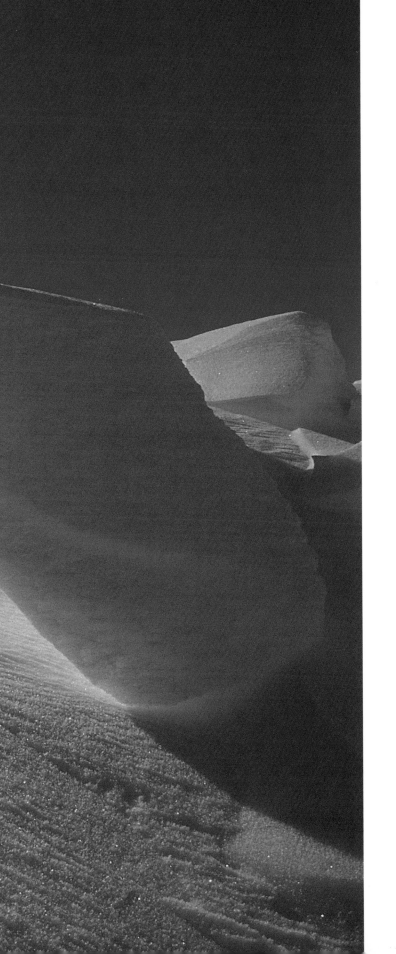

CONTENTS

PHOTOGRAPHER'S PREFACE

As I sit on the caribou calving grounds writing this, I am thinking about how lucky I have been to have seen so much of the North by such a young age. As I hope my photographs show, there is something surreal and magical about the North and its wild inhabitants.

The time and effort I put into my photography makes the most sense and seems the clearest when people ask me where or how I managed to capture an image on film. Recently someone asked me at which game farm I had shot the photograph of the wolf on page 41. I have never been to a game farm to photograph—not because I believe it is wrong but because I photograph more to experience powerful moments than just to take a picture.

I explained to my questioner that in the spring of 1994 I was dropped off by a small skiplane on the Barren Grounds, 300 miles north of the Arctic Circle. I wasn't to see another person for three months. In part I wanted to test myself and all that I had learned throughout my years in the Arctic, but I primarily wanted to photograph and to observe tundra wolves. After living on the tundra for nearly three months, I had hiked over 600 miles, lost 33 pounds, and managed only a couple of fleeting glimpses of the elusive wolf.

During one of my final long hikes across the tundra, I noticed what appeared to be a long, flat rock in a bed of lupine flowers. The rock seemed out of place, so I decided to take a closer look through my binoculars. I froze with excitement upon realizing that I had found the wolf I had been searching for. After an hour of crawling on my belly, I made it to a small clump of willows, only 20 yards from the wolf. I carefully pushed my 700mm lens through the branches of the willow bush and waited. When the wolf lifted his head to check his surroundings, I snapped a couple of shots. The sound of the motor drive momentarily startled the wolf, causing him to look into my lens long

enough for another two shots. He then got up and walked over to me to see who the strange visitor was hiding behind the bush. After satisfying his curiosity, he casually walked off into the distance.

That, I told my questioner, is how I got the shot. It took three months away from my wife, a lot of hiking, and some luck. I could easily have gone to a game farm, paid my $300 for the day, and photographed a mother with her pups and wolves feeding, playing, and posing. But I wouldn't have had such a memorable experience.

So when I look at my images, I don't see only pictures. I see the time I snowmobiled almost 4000 miles throughout the Arctic archipelago in search of polar bears, swam among several endangered 70-ton bowhead whales in the Arctic Ocean, had my arm sniffed by a young grizzly bear, was surrounded by eighty thousand caribou for two days, fell asleep next to three grazing muskoxen on Ellesmere Island and woke up to hear them grunting at me just 3 feet away, and spent five hours watching a female polar bear nurse and play with her two cubs on Baffin Island. And I have had many more such experiences.

I thank nature for providing me with those precious gifts and hope that I have been able to capture the essence of those moments on film. I look forward to more of nature's powerful experiences and will do my best to photograph them as well.

In the meantime, I hope you enjoy this book.

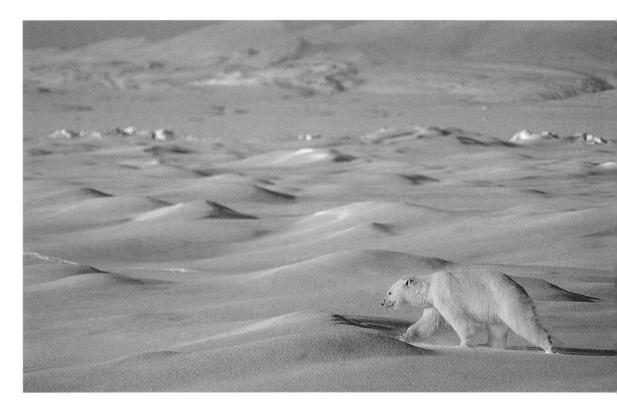

A solitary bear cruises the open sea ice near Ellesmere Island.

ACKNOWLEDGMENTS

OVER THE YEARS, I have traveled throughout the North and into some of the most inaccessible areas of the Arctic. The sheer size of North America's Arctic is staggering. The Canadian Arctic comprises over half the land area of Canada yet is populated by fewer than sixty thousand people. Because there are so few people and the locations are remote, travel can be both expensive and difficult and can become a logistical nightmare. Without the help of many key people and organizations, I never could have undertaken such a huge project. I sincerely thank you all for helping me make this book a reality.

A special thanks to my friends and hard-working biologists for allowing me to tag along on their far-reaching expeditions: Anna Chambers, Sue Cosens, Brett Elkin, Mark Gentili, Anne Gunn, François Messier, Fritz Mueller, Teresa Earle, Kim Poole, Rick Price, and Rob Stewart. To Brad Parker and Tamreesee Akittirq for all their patience, generosity, and logistical support. An extra-special thanks to Kerry Finley for sharing his passion for bowhead whales with me. Most of all, to Mitch Taylor, the extraordinary polar bear biologist, for sending me on extended snowmobile expeditions to the High Arctic in search of polar bears and for his belief in me and this project.

To Flip Nicklin, my friend and true mentor, for his unconditional support and belief and amazing advice. Thank you. To all my family and friends for their support and encouragement: David Nicklen, Louise Roy and Alex Fallow, Aaron Nicklen, Barbara and Fred Hartley, Harry Hole, Dr. Stuart Madden, and the Fenton and Montgomery families. To my good friends David Abernethy, Chris Humphreys, Brian Knutsen, Kevin Johnston, David Pelechaty, and Mike Vlessides for listening to all my crazy ideas. To Roberta Mark (Queen R) for her unconditional support. To Mike Claringbull, Glenn Macara, David Nolsoe, Greg Works, Pam Ellemers, Mary Tapsell, and Richard Weishaupt, and especially to Chris Hrkac for all his generosity.

To Barbara Black and Bill Hall for going beyond the call of duty in handling all my film and last-minute equipment requests.

To Glenn Williams for sharing his wisdom about the Arctic and to his wife, Rebecca, for the best batch of ooyuk a person could ask for. To Janet Troje for the great company and special treats after extended trips into the Arctic.

To my friends and fellow photographers for their great advice and inspiration: Daniel J. Cox, Natalie Fobes, Tom Mangelsen, Daniel Poleshcook Jr., Adam Ravetch, Nori Sakamoto, Tom Soucek, Yuichi Takasaka, Robert Taylor, Tom Walker, and Staffan Widstrand.

To my wonderful guides and friends for their strength and for sharing their lifetime of knowledge and skill: Andrew and Sarah Taqtu, Judas Taqtu, Danny Taqtu, Levi Illingayuk and Dora Jaypoody, Aaron Pilakapsie, David Poisey, William Kautuq, Mina Palluq, Mark Sabourin, Andrew Attagutaaluk, Adam Qanatsiaq, Pakak Qamaniq, Kevin Attaggutaluktuk, Seeglook Akeeagook, Caleb Iqaqqsaq, Timut Qamukaq, and the staff at Sila Lodge.

To Len and Bev Smith for giving me an exciting job at Tundra Buggy Tours and for the many adventures with my fellow buggy drivers, Mark Augustowich, Dennis Compayre, Charlie King, Mike Harrison, and Chris and Rob Watson. To Jean Keene for her generosity and for being so darn dedicated.

To Hugh Brody for writing such a wonderful text. To Rob Sanders, Terri Wershler, Leanne Denis, Val Speidel, and the rest of the gang at Greystone Books for their positive ways and for keeping the ball rolling and especially to Nancy Flight for such a great job with editing and pulling the whole project together. To Dean Cluff for the map and to Judy Farrow for plant identification.

Many thanks to NWT Air, Canadian North, and First Air for their assistance in flights around the North. To Annelies Poole, Season Osborne, Tom Koelbel, and *Above and Beyond* magazine for seeing the big picture. To the NWT Arts Council and NWT Environmental Action Program (AES) for providing much-needed funding when I was starting out.

To Lyn Hartley for remaining strong and supportive through our many months of being apart.

To any of those I have forgotten to mention in this extended list, I sincerely apologize.

Finally, to my favorite hiking companion, who never disagrees, my beautiful dog, Wolf.

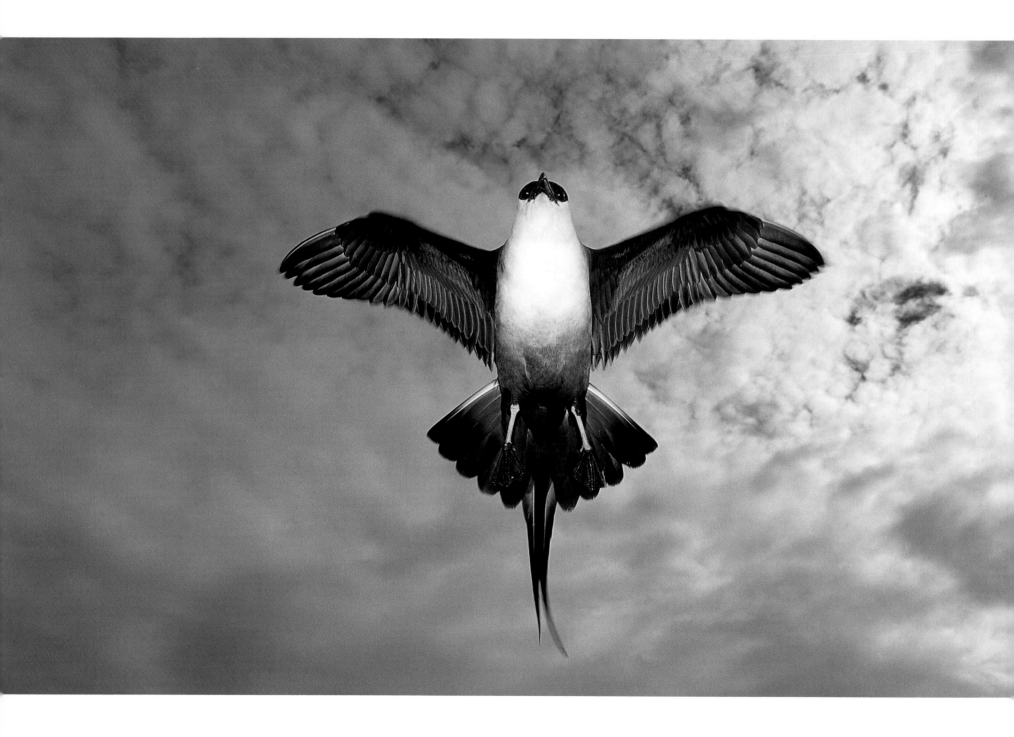

T HE ARCTIC HAS long inspired and confounded my imagination, creating a sort of geographical addiction. Like so many who have been fortunate enough to experience the land beyond the tree line in all its seasons, I discover a peace of mind only when I see, at last, even from the window of the airplane, a vast Arctic landscape, that terrain without forests, where nature seems to open up the world for all eternity. Paul Nicklen's photographs provide a chance to look again and again at the glory of the Far North.

Here are glimpses of the Arctic, fractions of time and space, caught in color photographs. They show the astonishing scale and astounding beauty of places and living creatures in this region. They reveal immense landscapes and minute details of the land. A hundred lakes on the Barren Grounds, the droplets of moisture on a ripe berry. Animals deep in their habitats, so close that their every detail is alive. And the elements: thick snow, the sea ice, rivers, the midnight sun, the aurora. These images startle with reality and yet are somehow surreal: they show both what is in the world and how the world inspires imagination.

The authority of photographs is, of course, their basis in an actual place and a definite moment. Photographs record what was there at the time. But some can also show what the eye in real life, doing its everyday job, rarely reveals. Pictures made with fast or long lenses, focused with perfect accuracy on some detail of the world or on some wild creature, taken by a photographer who has gone to places few ever see and has spared no pains to capture a perfect moment in nature, are both real and unreal. The more remote the place and the more elusive the subject, the more we are delighted by this reality, yet the less it belongs to the realm of ordinary experience. Thus can photography reveal as well as describe and create an intriguing mixture of the literal and the fantastic. It is this mixture—an ambiguity intrinsic, perhaps, to all photography—that allows a photograph to

FACING PAGE *A long-tailed jaeger displays its dramatic breeding plumage on the island of Igloolik.*

reach beyond the actual. When a photographer takes us where we otherwise could not go, be it to a spot on the earth or a point of view or a detail selected from the maze of reality, the more the photograph can excite the imagination. Photographers can make images that otherwise would not exist.

Paul Nicklen's photographs are indeed immaculate portraits of the natural world. And they take us to remote areas of a remote region. Paul Nicklen has made long journeys in difficult country to notice and "capture" scenes and moments that are as elusive as they are—for most of us—exotic. He offers us places and animals and inspiration.

The Far North lies at the margins of the known and inhabitable world: its extremes and variety are themselves a source of wonder, a nudge to the imagination. The facts, as well as the images, are fantastic. The best marker of where the Arctic begins is the tree line, the region—for it is not so much a line as a fading of one kind of place into another—where summers are too short and cool for trees to grow more than a couple of inches high. In the Scandinavian and Russian Arctic, the tree line is a strip of taiga and tundra that stretches halfway around the world. In Canada, the tree line roams from close to the Arctic Ocean in the west to the southern shore of Hudson Bay and then north again to the center of the Ungava Peninsula. Most of the photographs in this book were taken in the part of Canada that lies beyond this roaming tree line; a few were taken in the western Arctic, in Alaska, Yukon, and the Northwest Territories, where the trees in places reach beyond the Arctic Circle and where many of the conditions of the Far North are also to be found.

The Arctic is an area of the world whose extent is little grasped. The Russian Arctic is about 4000 miles across. Greenland is 1500 miles long, reaching from south of Iceland to a couple hundred miles from the North Pole. Within Canada alone, the length of the Arctic Circle—the line of latitude where the sun does not set on midsummer's night—is 2000 miles, running from the Alaska-Yukon border in the west to the east coast of Baffin Island. The greatest north-south distance of the Canadian Arctic, from south Hudson Bay to the top of Ellesmere Island, is about the same. To lay the area of Canada that lies beyond the tree line, including all its offshore islands, onto other regions of the globe is to find that it equals in size all of India, Pakistan, Afghanistan, Nepal and the Himalayas, and a bit of Tibet. If one were to do the same thing over Europe, the covered area would be all of Great Britain, Ireland,

France, Spain, Portugal, and Italy, the entire Mediterranean, Tunisia, and about a third of Algeria.

The varieties of landscape contained within this vast region are evident enough: tundra, mountains, shorelines, lakes, and great river systems. The widespread notion that these different topographical features are rendered homogeneous and lifeless by an extreme of climate is false.

Familiar stereotypes of the Arctic proclaim infinities of white, a deadness of extreme cold, grim silence, a darkness of winter. According to eighteenth-century theorists of exploration, bleak, endless, and unchanging vistas drove those who sailed Arctic coastlines into deep depression. The deep depression turned out to be a symptom of scurvy, while the shorelines and vast interior that lay beyond the journeys of the day were found to include many kinds of land and many kinds of climate. The farther north you go, the greater the variation of sunlight from one time of year to another and the more startling the differences between seasons. In every part of the Arctic there is great variation in wet and dry, cold and warm, light and dark, verdant and bare, level and steep. The plants and creatures of the Arctic have seized its many opportunities. So it is that Paul Nicklen's photographs display and celebrate many landscapes, every color, an abundance of life, a glory of light.

Temperature ranges within the Arctic are startling. A hot day during High Arctic summer can reach 68°F; a cold day in winter will be −40°F. While taking these photographs, Paul Nicklen once experienced 75°F on the Horton River, at seventy degrees north, 240 miles above the Arctic Circle; and, on another trip, two weeks of −49°F or colder near Yellowknife, in the Canadian subarctic. The range of 108°F between warmest and coldest days of a High Arctic year may seem less remarkable than the potential for change in Arctic temperatures within seasons. A summer's day may reach 68°F; it can also plummet to 32°F. One winter's day may remain at −40°F; another might be 23°F.

To this inconsistency of temperature can be added the difference between conditions in the open

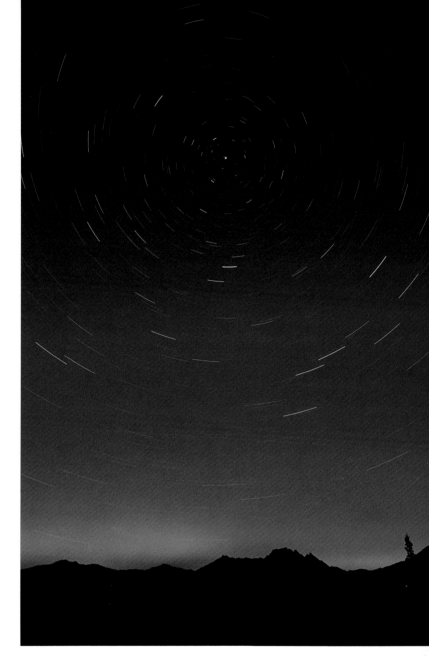

A two-hour exposure reveals the path of the stars, encircling the North Star, and a hint of aurora over the Alaska Range.

and those beneath protective surfaces of snow and ice. There are many climates in the circumpolar Arctic, in Siberia as well as in Alaska and Canada's Northwest Territories, even during winter.

In an Arctic storm, the notorious wind-chill factor can more than triple the intensity of cold: a thermometer reading of $-22°$F becomes an effective temperature of $-76°$F. In these conditions all atmospheric moisture freezes and falls to the ground as frost crystals. Water turns to ice in a few seconds. But however cold the air or fierce the wind chill, snow can provide crucial protection. Because minute pockets of air—which does not conduct heat or cold—are trapped in its structures, snow creates a dense cushion of shelter and insulation. Under the snow, among grasses, or in burrows, animals can live in microclimates where the air temperature may be $122°$F higher than on the surface, only a couple of inches away from them. In the same way, though without the advantage of trapped air, ice protects water from the chill of the air. Beneath the ice, which may be as much as 6 feet thick, the water temperature can thus remain close to or above freezing. Fish and seals move, feed, and breed beneath the Arctic Ocean. At the coldest times of the Arctic year, life on the open land and sea ice is possible for those few creatures that can hunt the many that live in relative warmth below the surfaces. Wolves and foxes search out lemmings. Polar bears lie in wait for seals.

Fur, down, and fat provide insulation; thus, survival—for animals and humans alike—depends on layers of fat, fur, or downy feathers. The blubber on sea mammals can be a couple of inches thick. The double fur of a muskox creates insulation eight times as effective as the wool of a sheep. The fur of caribou is both dense and hollow, thus creating a cushion of air, an ideal form of insulation. Birds can protect themselves against cold by fluffing themselves to twice their normal extent of down and feathers, thereby doubling the volume of trapped and insulating air.

One of the most surprising features of the Far North is the quality of sound. In spring and summer the songs of snow buntings, the shrieks of falcons, and even the wing beats of oldsquaw ducks carry extraordinary distances. At mating time, the *goback, goback* of ptarmigan calls and the sudden throbbing of the wings of a male spruce grouse have an astonishing volume. In breaking ice, at a floe edge, the strange moans and whistles of an adult male narwhal or the bursting blow of air by a huge bowhead whale can be heard across a mile or more and with such clarity as to make distant animals seem close by. Even in winter, when you might expect the profound silence of a frozen

world, the sounds of ice cracking or wind beating on snow, the howl of a wolf, or the crunch of footsteps all seem to be amplified, as if the air itself were resonating.

The Inuit, among the most sophisticated of all experts on the qualities of the Arctic, divide the year into six seasons. They speak of *upingaassak*, the season of anticipation of spring. This is a time of fresh, heavy snow and many storms, of blizzards and drifts. The days become longer and longer. When the sun shines on the sea ice and snowfields of the tundra, there is a sudden reflected heat. The first snow buntings appear, followed by horned larks and snowy owls. Deep snow has accumulated on the sea ice; it is here, where the snow allows a ringed seal to excavate a safe cave in the snow above a breathing hole, that the females give birth to their one or two pups. Polar bears search for these dens, sniffing the snow and discovering where to break into them to find baby seals. Lemmings give birth in their nests under the snow. The large caribou migrations are under way, moving from the edge of the tree line into the tundra. Wolves and ravens follow these herds as they move north.

Then comes *upingaak*, spring. The sun beats down; snow melts off the land; streams and rivers are bursting with floodwater and breaking ice. In the Far North the sun no longer sets. Flowers and grasses explode into life: saxifrages, poppies, bog cotton, the bright leaves of dwarf willows, bearberries, and cranberries. In every tundra pool and among its grasses, mosquitoes emerge, breed, and swarm in vast clouds. In drier places, even in the High Arctic, butterflies, spiders, and bumblebees appear. Different kinds of melt water create a glory of blues and greens on the surface of the sea ice. Mice and lemmings are no longer safe under snow: owls, foxes, and jaegers hunt them day and night. Migrating eider ducks, scoters, snow geese, plovers, sandpipers, phalaropes, swans, murres, loons, terns, fulmars, and several species of gull, along with buntings, larks, and falcons, appear in their hundreds of thousands, flying to nesting sites on the tundra, cliffs, and shorelines. The creatures that have mistimed a change of color stand out, and in the highest Arctic those that stay white all year gleam against the land. But many birds and animals change color: for a short time ptarmigan, snowshoe hares, foxes, and even weasels are startlingly visible; after they become camouflaged in colors of the tundra, they disappear. With this abundance of life, foxes begin to bury and store carcasses and eggs that they do not eat. Caribou move toward their calving grounds, traveling as far as they can to escape pursuing wolves, which at last must pause to have their cubs. Ringed seals and their new

pups lie beside their breathing holes and bask in the sunlight. Polar bears begin to teach their cubs to hunt.

By the end of *upingaak* the ice has begun to move, wear, and fracture. Long and widening cracks appear, creating dark lines of sea where seals and birds congregate. The breaking and melting of the ice releases microscopic organisms into the sea; these are the nutrients for the copepods and krill that now appear in Arctic waters in their millions. Narwhal and bowheads swim along leads in the ice and among the increasing mass of floes at the edge of the fast ice, seeking the copepods and krill on which they will be able to gorge. At length the sea ice breaks, moves, and (almost every year) disappears into pans and fragments.

Aujak, or summer, is the time when the Arctic is free of snow and the sea ice has given way to open water. The land is muted, the tundra wet; until the first frosts of late *aujak* mosquitoes continue to swarm. Grasses and flowers have formed their seeds. Berries are ripe. Even in the High Arctic the sun sets. By the middle of *aujak* days and nights are more or less of equal length. There is rain and fog, as well as sunshine. Sea mammals move freely along the shorelines: beluga and narwhal move into bays and fjords to feed and calve; bowheads appear, either as solitary individuals or in groups of fifty or more, off the northernmost headlands and islands of the High Arctic. They are now moving toward their feeding grounds, which are farther south but still within the Arctic Circle. Large groups of harp seal can be seen offshore. Caribou herds, their numbers increased by the year's new calves, are gathering on the tundra. They feed all day on mosses and lichens, building up fat and strength for their return migration to the south. They also find windswept ridges where they can escape the torment of mosquitoes. Birds have finished nesting; groups of plovers, sandpipers, and phalaropes dart along shorelines. Flocks of murres and black guillemots leave their nesting sites on cliff faces and rocky islets, spreading out to feed in every bit of open water. The geese, molting and changing plumage, are unable to fly. Arctic char are beginning to migrate from the sea into lakes.

After *aujak* comes *ukiassak*, or autumn, literally "material for small winter"—the anticipation of cold. The temperature drops; the first snows fall; ice forms on freshwater lakes. The caribou have a thick layer of fat along their backs, and their new fur is dense and short—at its best for winter cloth-ing. But as the weather gets colder, caribou also grow long, pale guard hairs, giving them extra insu-

lation and a whiter appearance. Arctic char now crowd into the rivers, making their way upstream to the lakes where they will spend the winter, under the protective safety of ice. Insects, frozen in water or hidden in roots and grasses, either at the point of death or in the pupal stage, have disappeared.

By the end of *ukiassak* most birds have flocked and are moving south, but groups of eider ducks, oldsquaw ducks, and some species of gull continue to feed on the shoreline. Skeins of geese are flying south but stop at feeding sites throughout the Arctic to rest and feed. Some snowy owls have left; in a good year for lemmings, when nesting has been successful, many delay in the North, continuing to feed, hunting those slopes that are still bare of snow. Wolves, foxes, snowshoe hares, weasels, and ptarmigan—creatures that survive the winter with camouflage—are turning white. And this is the season for the most brilliant aurora, when, as the Inuit say, children dance and play in the night sky.

Then comes *ukiak*, the small winter. The land is now covered with new snow; the sea ice forms; the winds blow hard and bitter. Ringed seals are living at their breathing holes. Female polar and grizzly bears enter their dens to give birth. The large caribou herds have migrated into the sheltering forests of the subarctic. The small herds that stay in the Arctic seek valleys where the wind has bared enough moss and grass for them to feed. A few ravens and falcons remain in the High Arctic; at the edge of the trees, and in the subarctic forests, ravens and gray jays scavenge throughout the hardest weather. Ptarmigan live on the snow; as the snow level moves up the willows, the birds can reach more and more of the buds that will sustain them through the coldest weather. Beneath the snow cover, in all parts of the Far North, ground squirrels hibernate in their burrows and dens while lemmings move around and feed in their runs in the grasses. Weasels slip back and forth between the safety of dens under the snow, where they hunt, and the surface, where they look for dead victims of the cold. Foxes dig for lemmings as well as scavenge.

The next and coldest season is *ukiuk*, full winter. The snow is deep and wind-packed—at its best for making snow houses. The days are very short. Beyond the Arctic Circle, midday is marked by a spell of twilight. When the moon is large, the snow reflects a soft, clear light—enough for hunters to see their way. At the coldest time, the weather is often still. Seals keep their breathing holes open by surfacing in each one in turn and scraping away new ice with the sharp claws at the tips of their flippers.

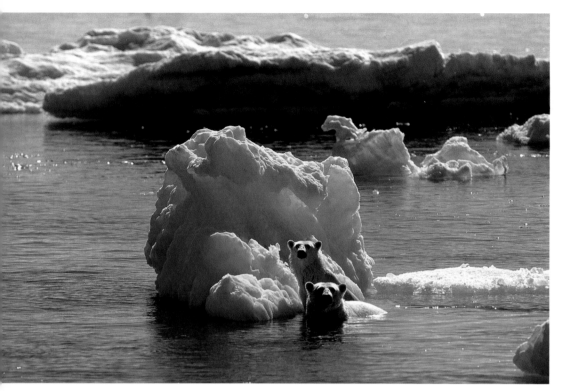

Under the snow, the life of lemmings and weasels continues, the one being preyed upon by the other, while foxes dig into any place where they can find access to this haven within the winter. They also now dig up their buried supplies of meat and eggs, hidden earlier in the year for this time of greatest cold. In the areas near the tree line, lynx prey on snowshoe hares, ptarmigan, and grouse. Wolf packs hunt for muskoxen and caribou; on the coldest and darkest days, wolves stay in touch with each other by howling. Under the ice of the deepest lakes, arctic char and lake trout move slowly in the warmest water, close to the bottom. In the Far North, the sun reappears, a tiny gleam across the cold.

These are the six seasons of the Arctic. Some aspects of the Arctic year, some forms of weather, and some movements of mammals, birds, and insects would be familiar to those who live farther south. Yet there is something about the lack of trees, the absence of any forms of agriculture, the lack of almost any roads, the abundance of water and ice in the thousands upon thousands of lakes and bays, and the abundance of snow that gives the Arctic its strange and overwhelming impact. For a photographer, as for the traveler, the light of the Far North is also its magic. In most parts of the world, sunrise lasts a quarter of an hour and sunset about half an hour. In the Arctic, when the sun makes a slow, incandescent loop across a wide arc of the horizon, sunrises and sunsets can last three or four hours. There are many weeks when sunrise and sunset are joined, a continuous midday of dusk and dawn.

Even in *upingaak* and *aujak*, the real spring and summer, the seasons most familiar to southerners, there are sights that fill the traveler with awe. The tundra's extent and surface; the influence of the permafrost, which lies at the most 7 to 8 inches below the surface; the maze of shallow lakes; the fjords that cut far and deep into coastal mountains. The sight of a snowy owl

A mother and cub take a rest from swimming the Arctic seas by nudging onto a small chunk of floating ice.

moving over the land in search of lemmings; the glimpse of a group of wolves moving alongside a herd of caribou. The explosion of breath from a bowhead whale and the raising of its vast tail flukes above the sea; the mottled backs of narwhal and the sudden whiteness of beluga as they move in family groups into a bay or river mouth. In the other seasons, when the extremes of the Arctic are all the more startling, these are landscapes and habitats that evoke deep wonder. So many adventurers into the North have spoken of finding reality—here it is, a land that makes almost all other experience somehow smaller, less compelling, less real.

Hunter-gatherers speak languages that express with a powerful mixture of fact and poetry their immense understanding of the natural world. The people of the Arctic are no exception: Inuktitut, the language of the Inuit, describes the land and its creatures in astonishing detail. There are words for ringed seal, young ringed seal, one-year-old ringed seal, and adult male ringed seal. And there are words for arctic char, char that are migrating upstream, char that are migrating downstream, and char that are resident in fresh water. Similarly, there are words for falling snow, freshly fallen snow, soft snow, blowing snow, snow that has melted and refrozen, snow that is good for building snow houses. Yet there is no word for seals as a whole or the things that are fish or snow in general.

Inuktitut is a language of specifics, of detailed knowledge, and does not rely upon the kinds of categories we find, for example, in all Indo-European languages. Nor are there roots to the specific words related to ringed seals, char, or snow that suggest categories—each term is quite distinct. Falling snow is *qaniq*; fresh, soft snow is *aput*; blowing snow is *mau*; snow for snow houses is *illuvigassak*. The beauty of the language is its focus on the actual things it names rather than on principles of language or science that organize these things. And for Inuit, like all hunter-gatherers, the relationship to knowledge and the links to the world in which they live are as direct as can be. Survival, after all, has always depended on being as close as possible to the natural world.

Photographs are without words, silent. Photography of land and animals, of wild places, can seem to imply that they reveal a world beyond or prior to culture. This book is a celebration of Arctic seasons and does not portray the many peoples of the Arctic who know and name each time of year. Nor does it display the multitude of names that Inuit, Dene, Innu, and other peoples of the North American Arctic give to all the places, elements, and creatures that these pictures bring to us. The

emphasis is on the natural, not the human, on the raw materials of the North, as it were, not their place in systems of knowledge and economics. But the photographs in this book can perhaps be looked at through the eyes of the hunters, the Inuit. Each one is a piece of their world and invites a form of knowledge. Forget the categories, including that of "Arctic," and see the place and its creatures for what they are—separate, extraordinary, and, here at least, right in front of our eyes.

Paul Nicklen's own knowledge and delight in the Arctic have been grounded in living there, among its people. For ten years his homes were in Lake Harbour and Frobisher Bay, Inuit communities in the eastern Arctic. He then moved to Yellowknife, the principal town and administrative headquarters—until the creation of Nunavut—of the Canadian Arctic. His photography has its heart, however, in the high, eastern Arctic. Nevertheless, the five years of work represented in this book has also taken him to remote areas in the western subarctic of both Alaska and Canada.

As he traveled in this region, coming close enough to its wildlife to take these photographs, Paul Nicklen says that the Inuit taught him to see the land, the sky, the hazards, the weather, and the ways of Arctic animals. Thus, he has said, the Inuit have instilled in him both his passion for the North and his ability to travel there; with them he found the confidence to work as a photographer, to hunt with a camera. Inuit guides took him for long trips to the floe edge and around Ellesmere Island. But on most of his photographic hunts, he travels alone. These are the photographs of someone who has both the knowledge and the daring essential for this work.

This book is not a portrait of wilderness, however, so much as a celebration of a vast region that has been named, traveled, and used in its entirety by the genius of indigenous societies. What those who live far away see as remote landscapes, and the creatures of a wilderness, Arctic people delight in as home and as resources. As we look at these photographs, then, we can experience a double sense of wonder: at what we see and how it is seen by others. For all their apparent perfection, silence, and stillness, these photographs, beautiful and compelling, will be looked at in many ways. Here also is their power to inspire—for what they allow us to imagine as well as for the things they bring so close. Paul Nicklen's photographs thus lead to the real and the unreal, that which is in the Arctic and that which makes the Arctic an addiction. They show places and animals and inspiration of a scale, strangeness, and beauty that come from a vast landscape, an immense natural world.

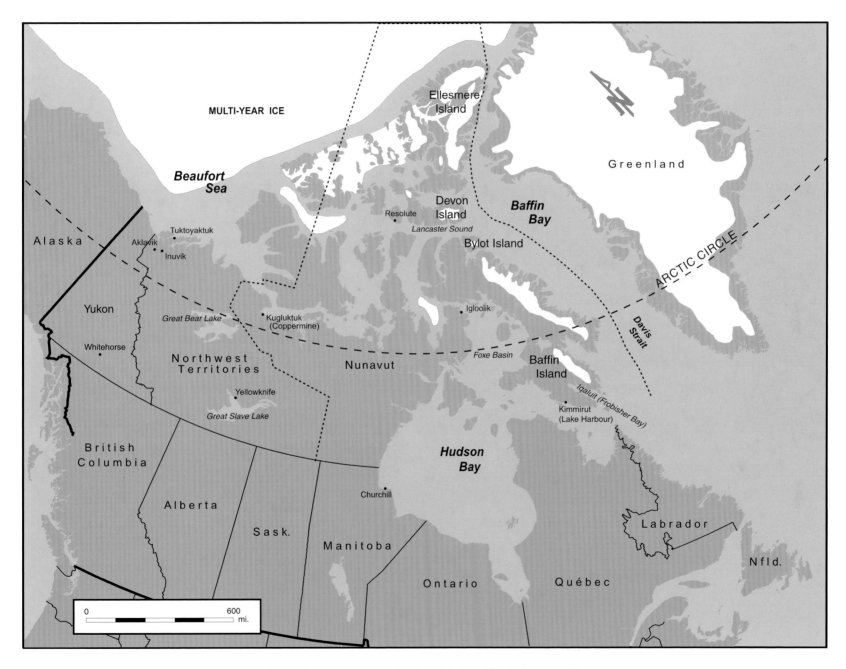

MULTI-YEAR ICE

Beaufort Sea

Alaska

Yukon

Tuktoyaktuk

Aklavik

Inuvik

Great Bear Lake

Whitehorse

Kugluktuk
(Coppermine)

Northwest
Territories

Yellowknife

Great Slave Lake

British
Columbia

Alberta

Sask.

Manitoba

Ellesmere
Island

Greenland

Resolute

Devon
Island

Lancaster Sound

Bylot Island

*Baffin
Bay*

Igloolik

Foxe Basin

Nunavut

Baffin
Island

Iqaluit (Frobisher Bay)

Kimmirut
(Lake Harbour)

*Davis
Strait*

ARCTIC CIRCLE

*Hudson
Bay*

Churchill

Ontario

Québec

Labrador

Nfld.

0 600
 mi.

THE NORTH AMERICAN ARCTIC

SEASONS
OF THE
ARCTIC

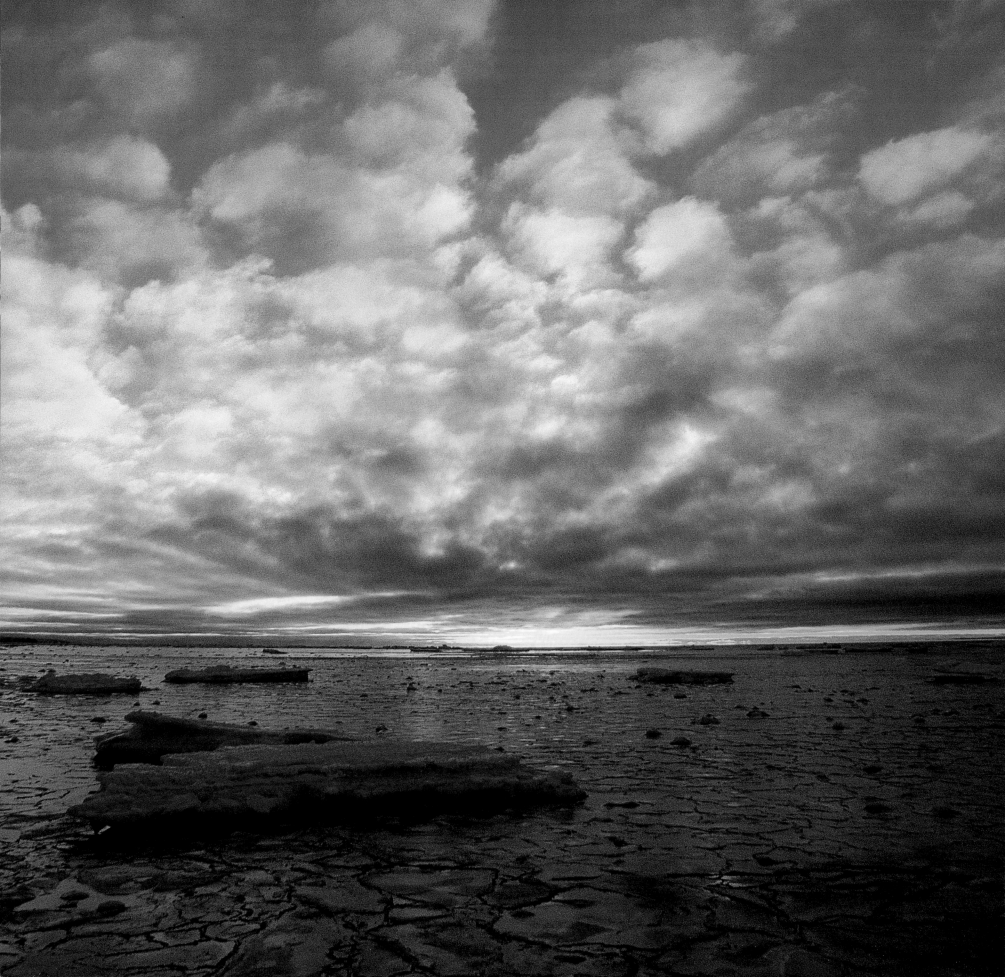

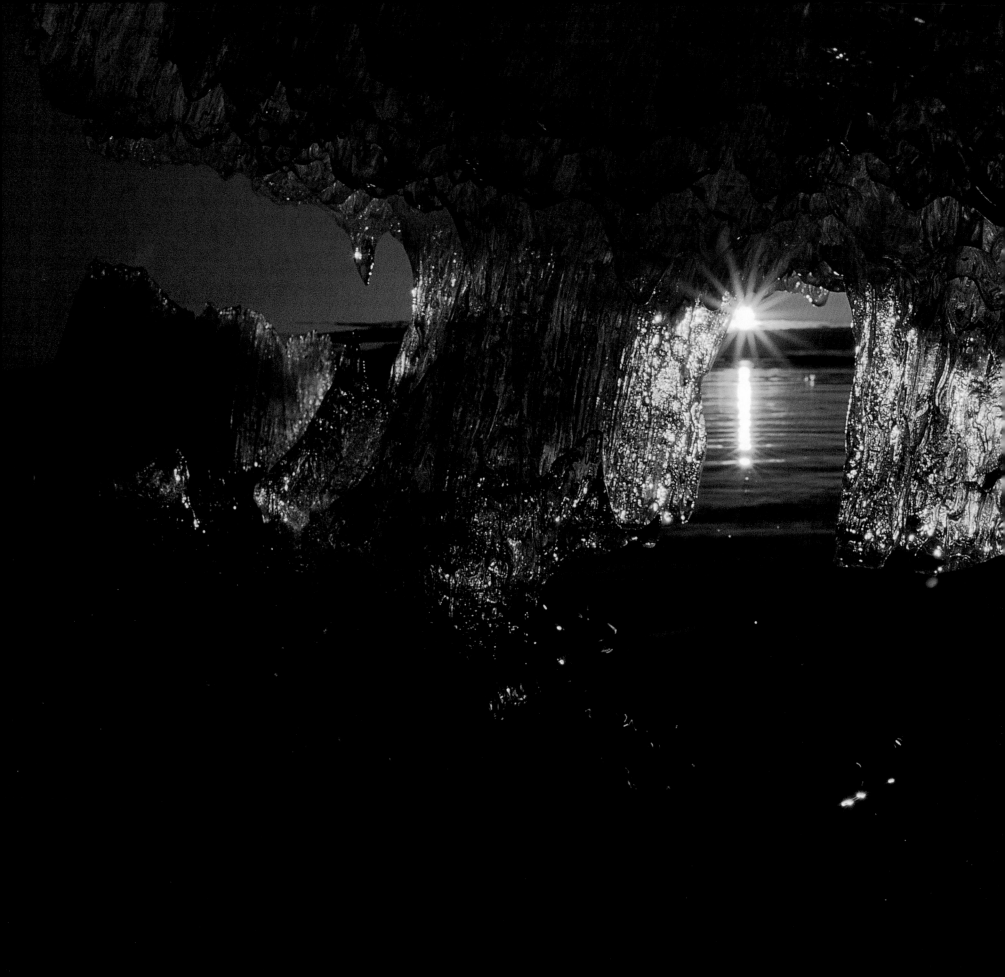

PAGES XXVI–1 *Along the shores of Hudson Bay, winds from the northwest combined with cold weather cause trees to have stunted branches or no branches on one side. These trees are commonly known as flag trees.*

PAGE 3 *A spectacular sunset paints the horizon gold over the seas surrounding northern Baffin Island.*

LEFT *Candling ice pillars are illuminated by the sun at 3:00 A.M. in spring. Soon the ice will be gone and the sun won't set for three months at this latitude.*

A curious bear walks through a
fantasyland of massive chunks of ice
created by the ebb and flow of the
large tidal exchanges of Devon
Island.

6

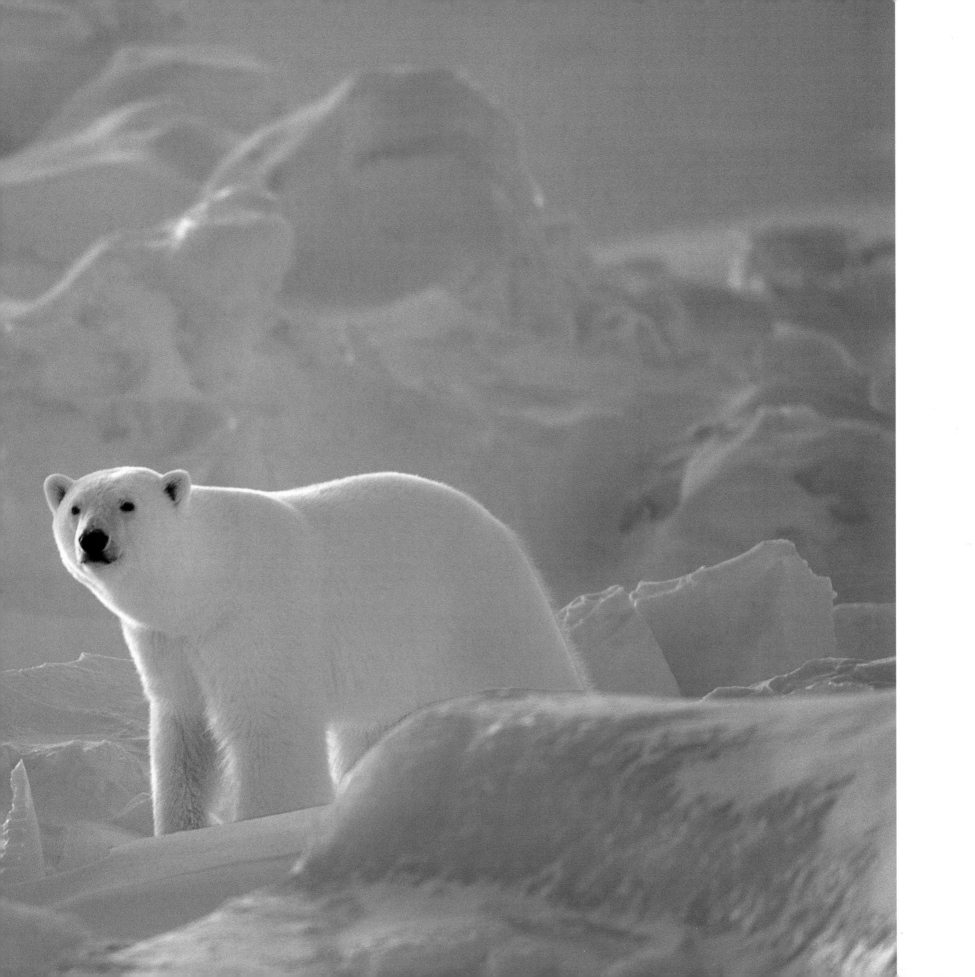

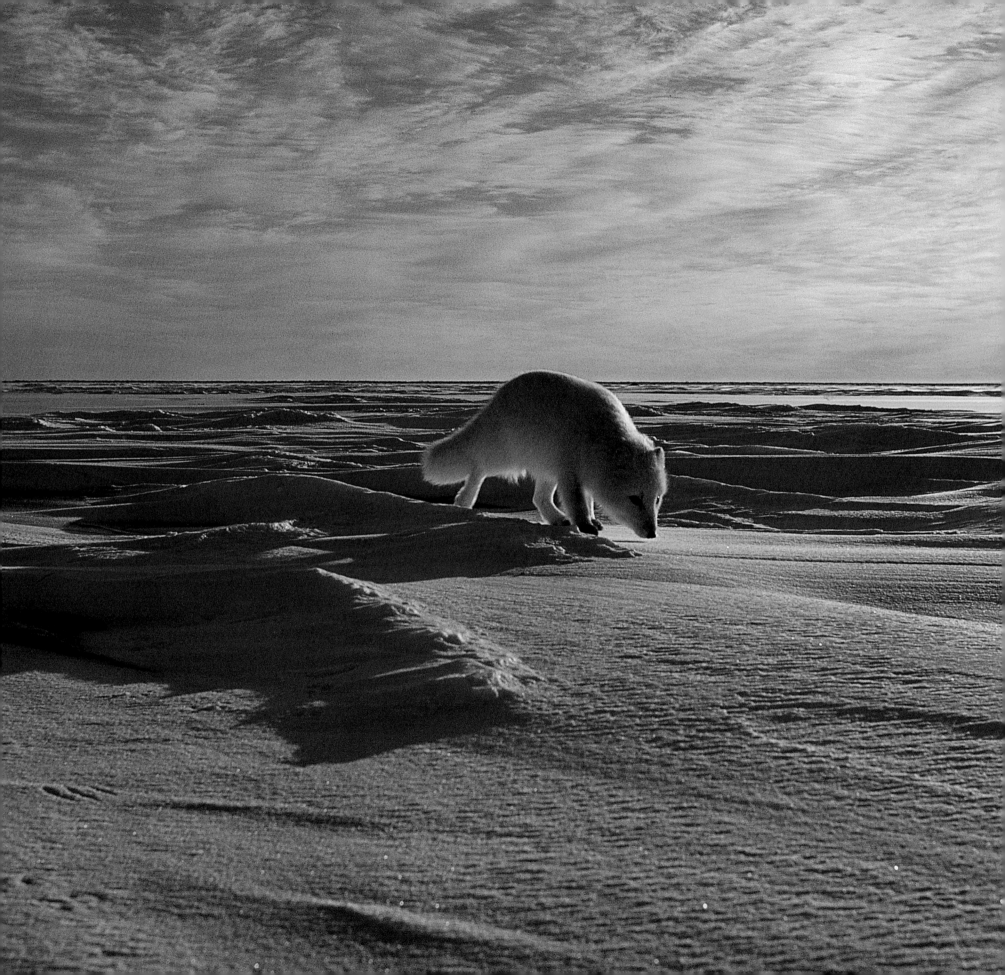

An arctic fox patrols the shores of the
Arctic Ocean looking for any scraps
that a polar bear might have left
behind.

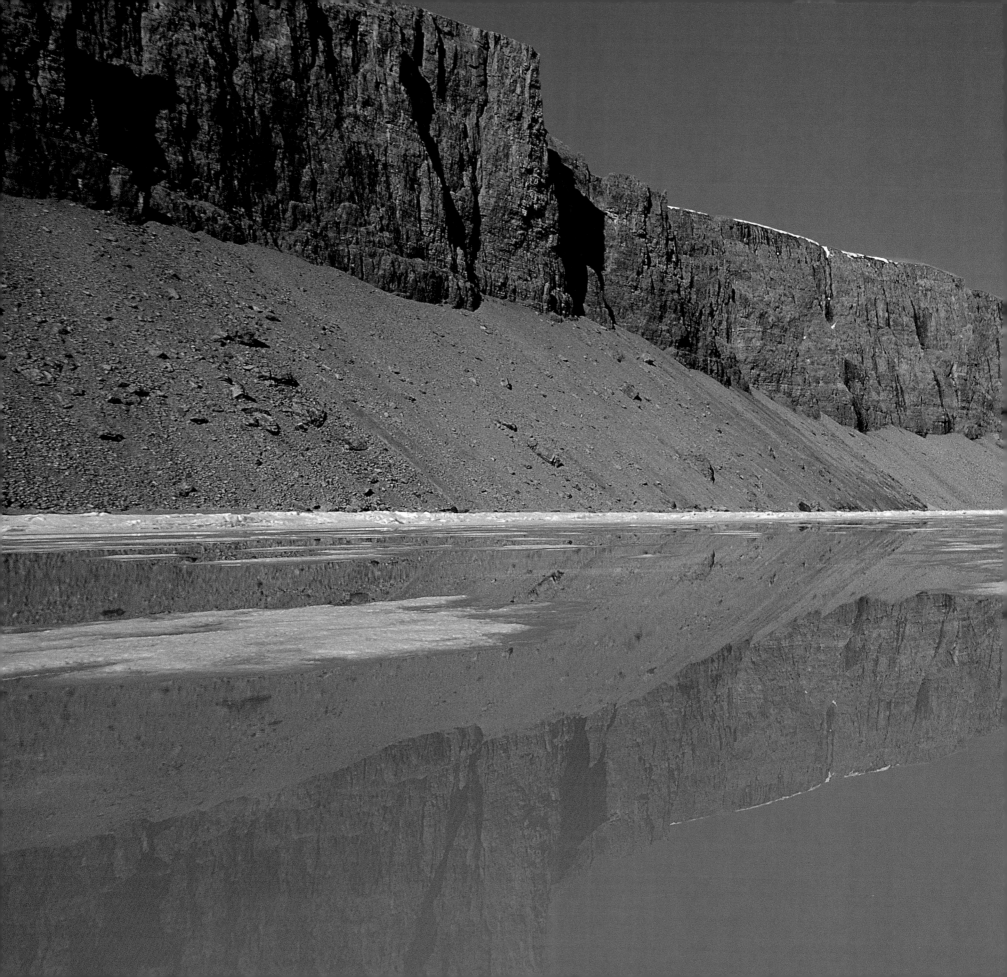

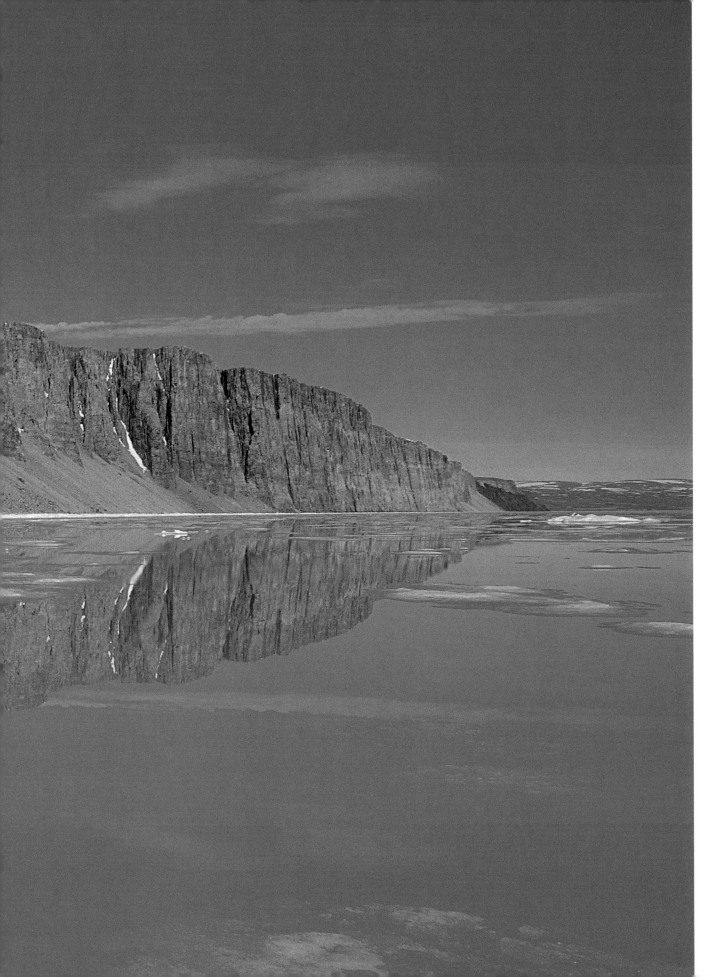

Cliffs along a Baffin Island fjord are reflected on the sea ice, which is covered by fresh water from snow melt and which is still relatively thick. In a couple of weeks, the ice will start to break up and these cliffs will be filled with nesting birds.

11

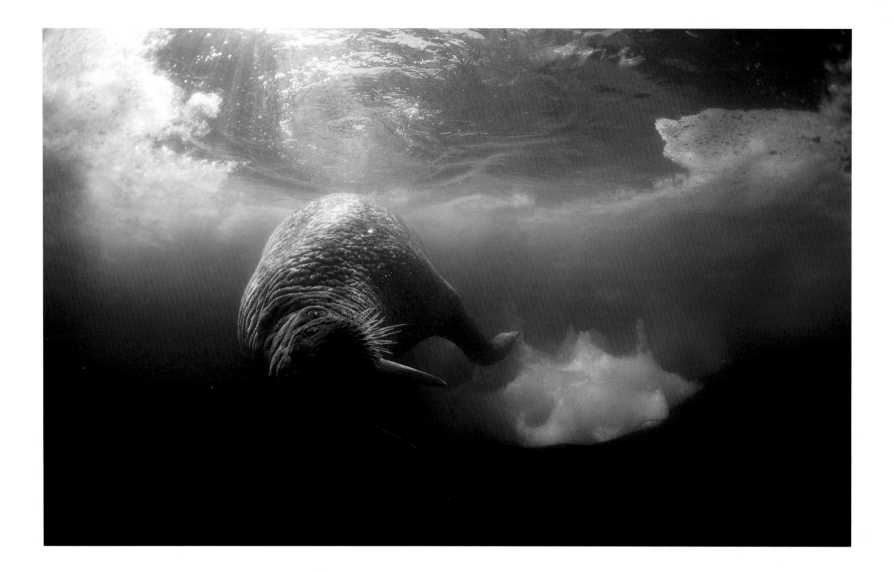

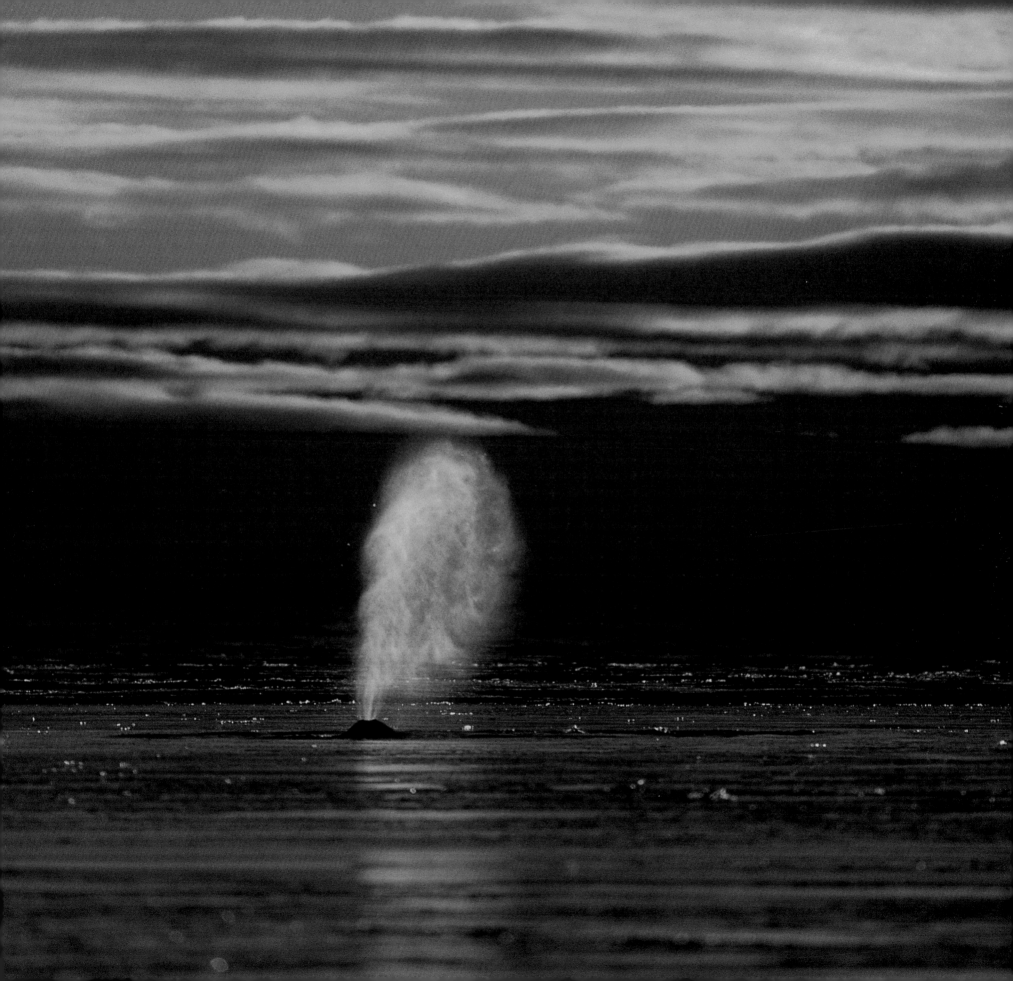

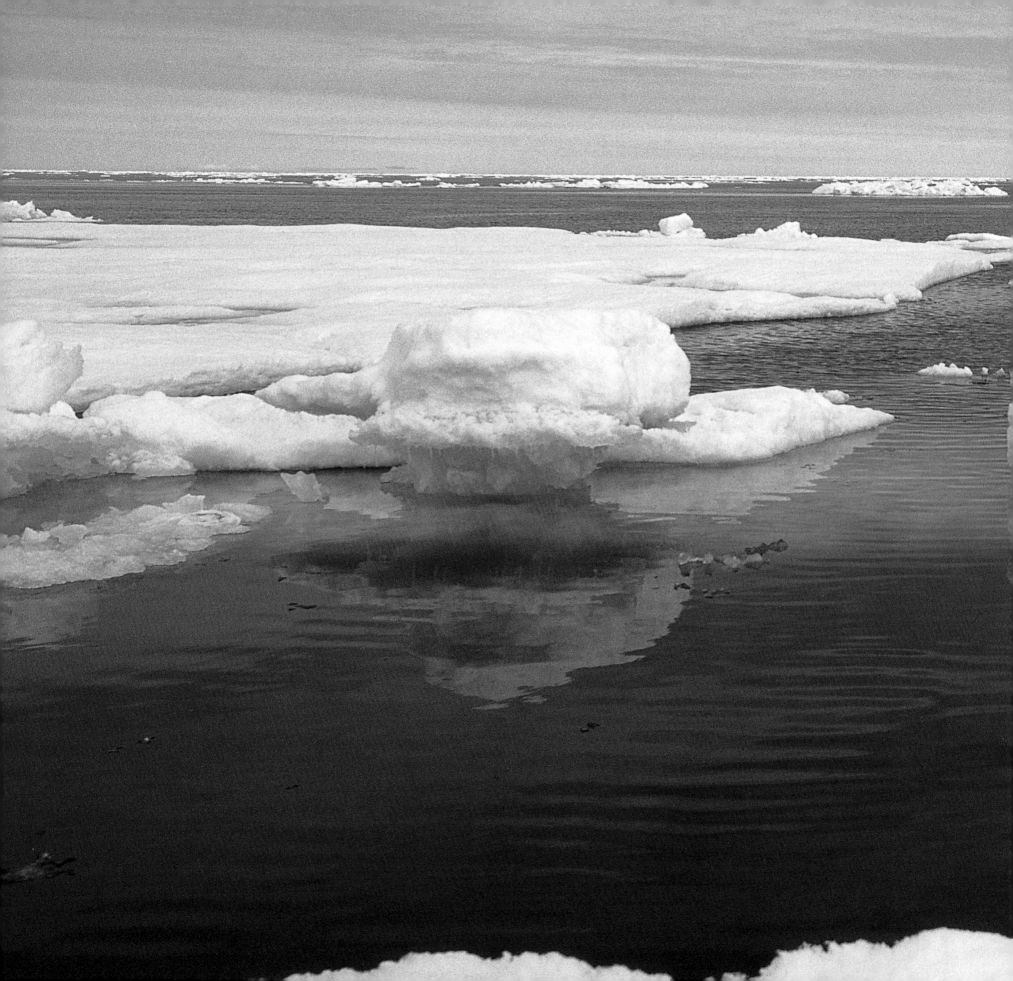

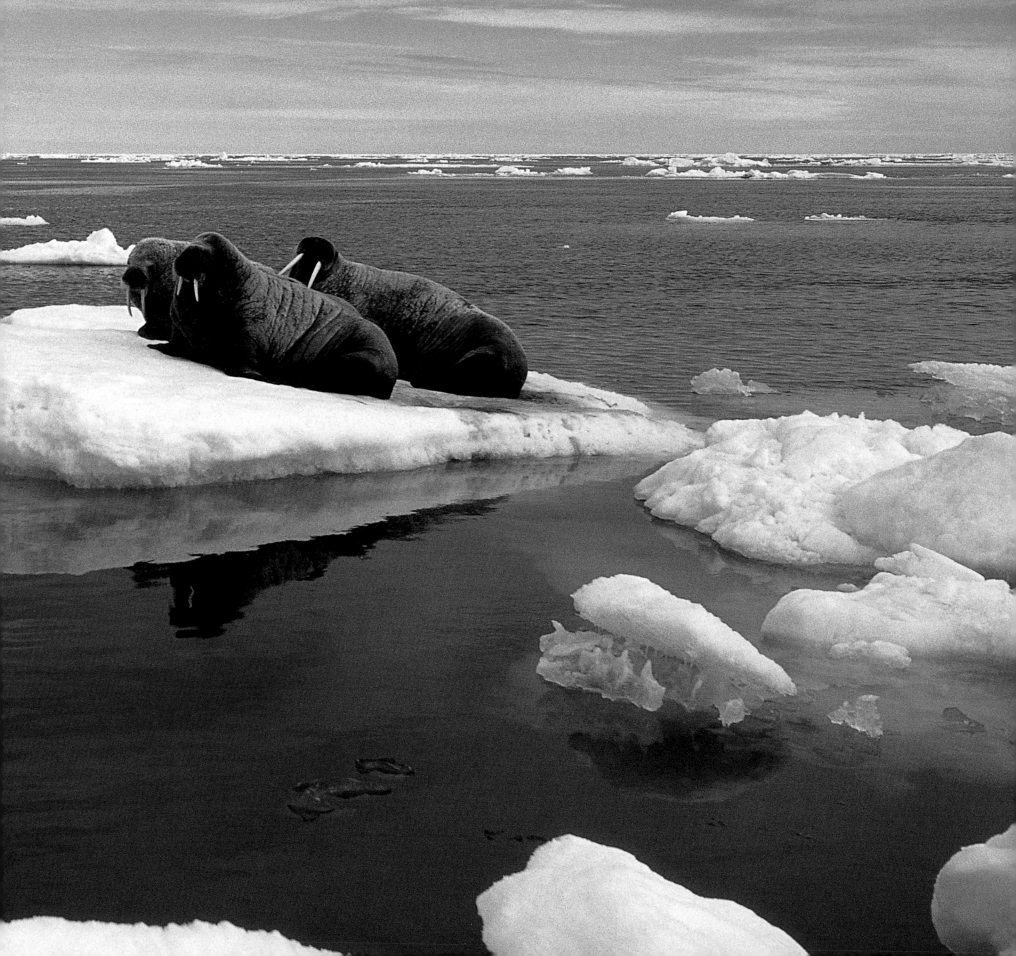

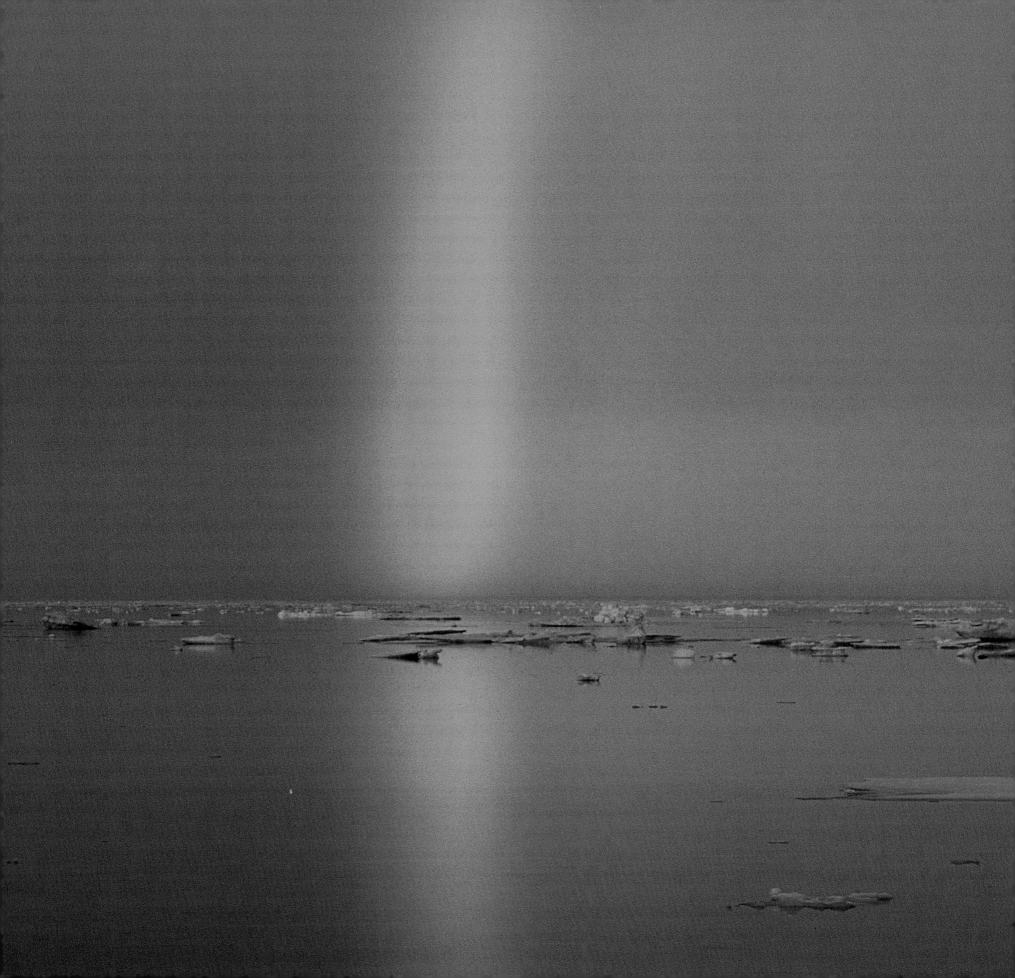

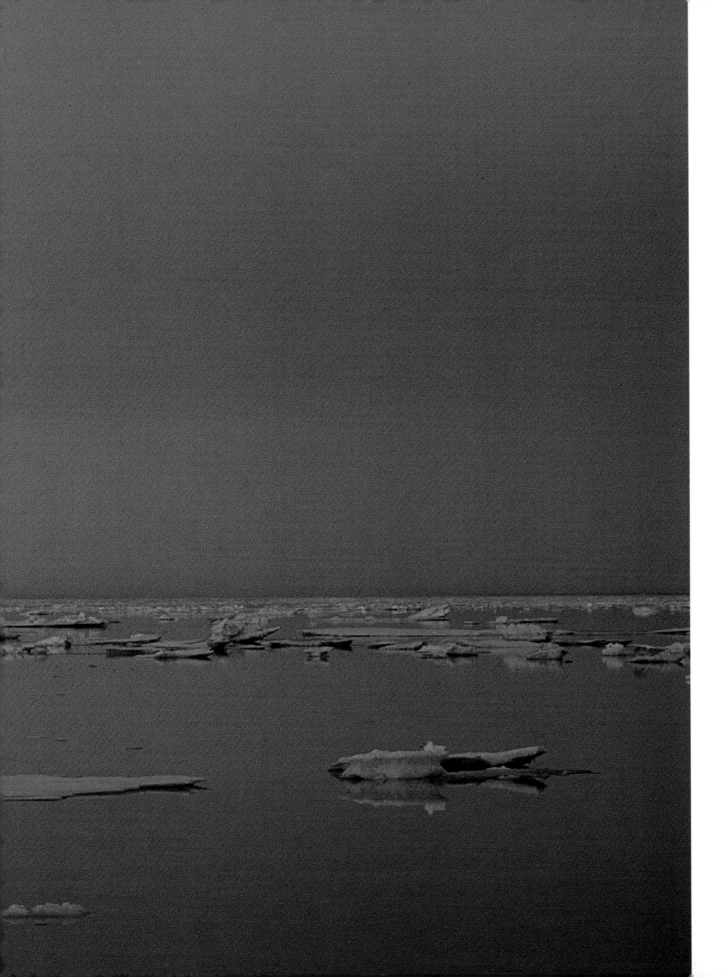

PAGE 12 *The Atlantic walrus shown in this rare underwater photograph lives in a world of constantly shifting pack ice.*

PAGE 13 *A bowhead whale exhales just before diving under the floe edge to eat its fill of copepods, euphausiid shrimp, and amphipods being funneled down from Lancaster Sound.*

PAGES 14–15 *Atlantic walruses enjoy a late-spring sunbath on drifting pack ice. Here the sea is shallow, providing easy access to an abundance of clams.*

LEFT *On a tranquil evening, a fog bow forms over the Arctic Ocean as the sun skims over the horizon.*

1 7

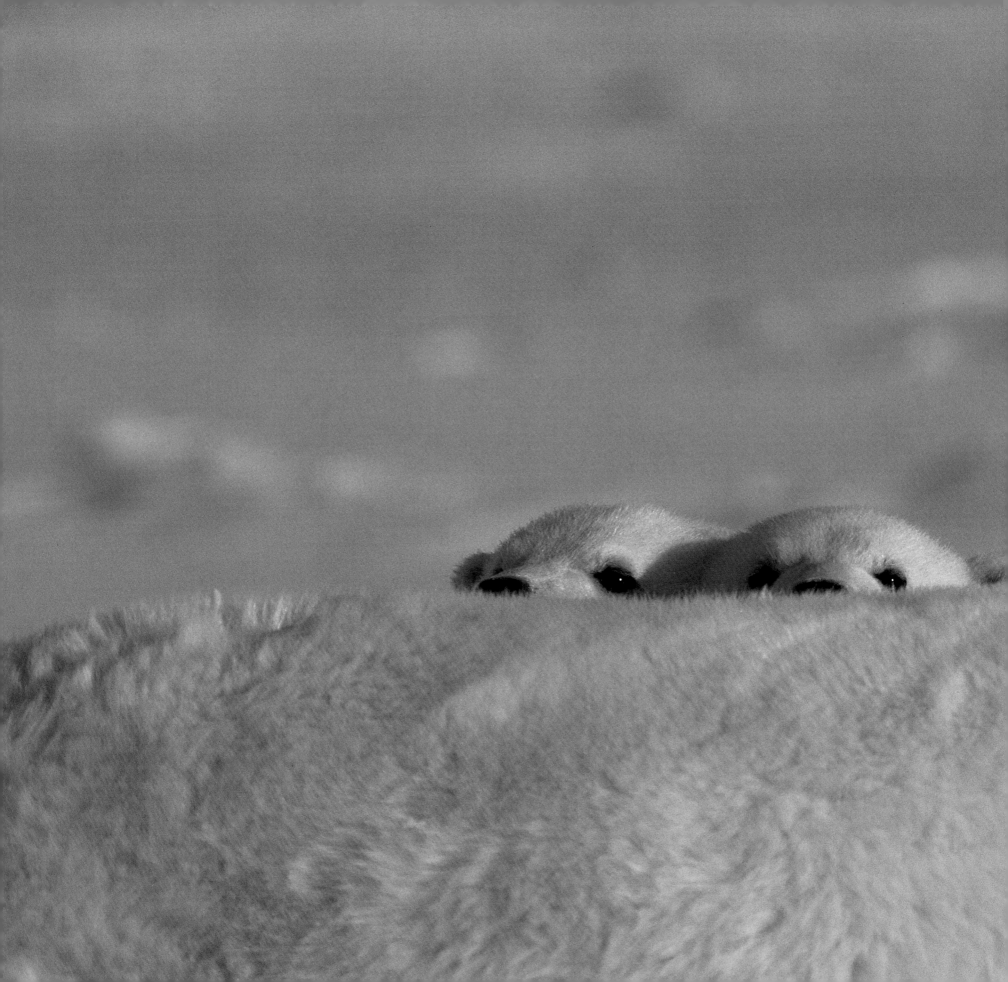

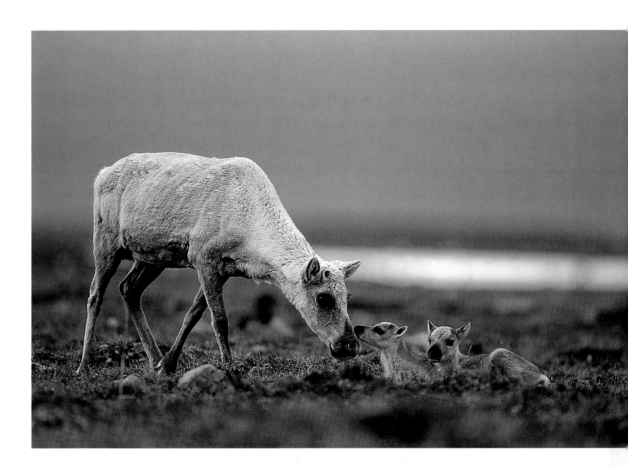

LEFT *These four-month-old cubs hide behind their mother's protective body. They will stay with their mother until they are 2½ years old, when the young males can be as large as she is.*

ABOVE *Just minutes old, these caribou calves will be up and running within half an hour.*

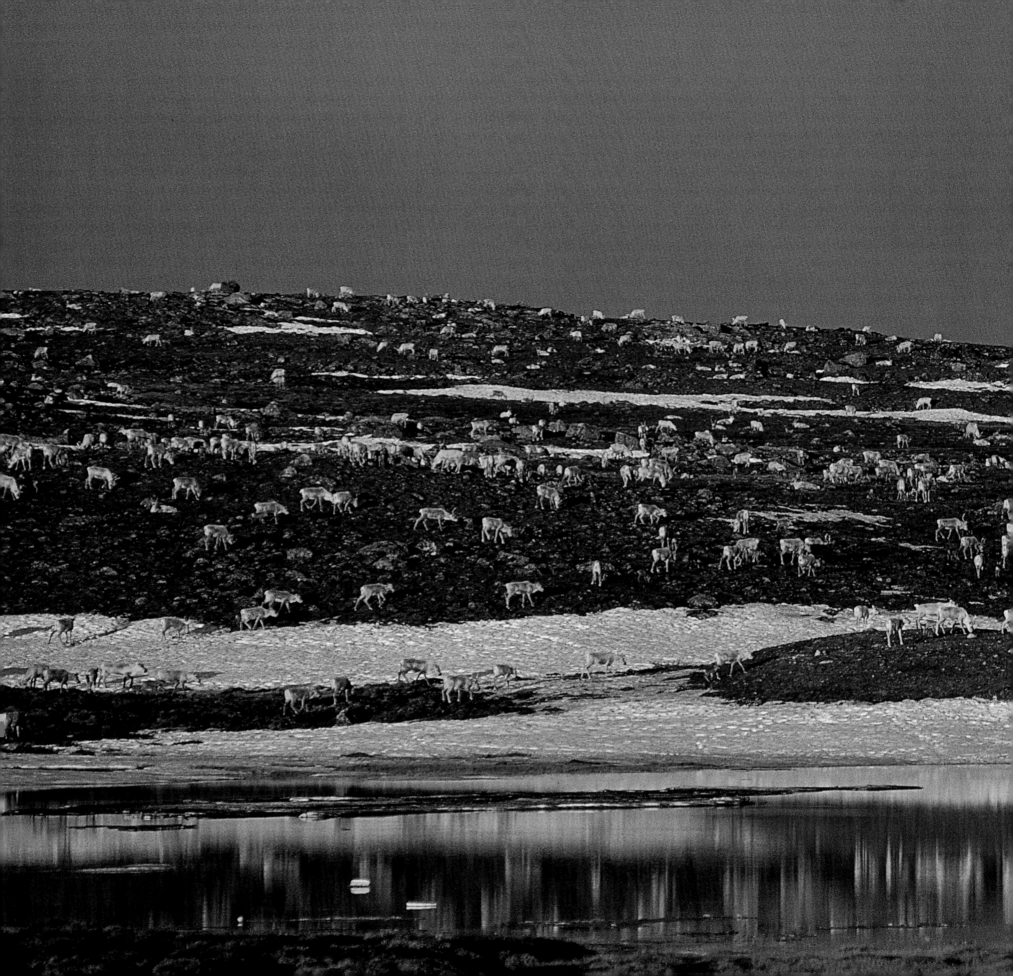

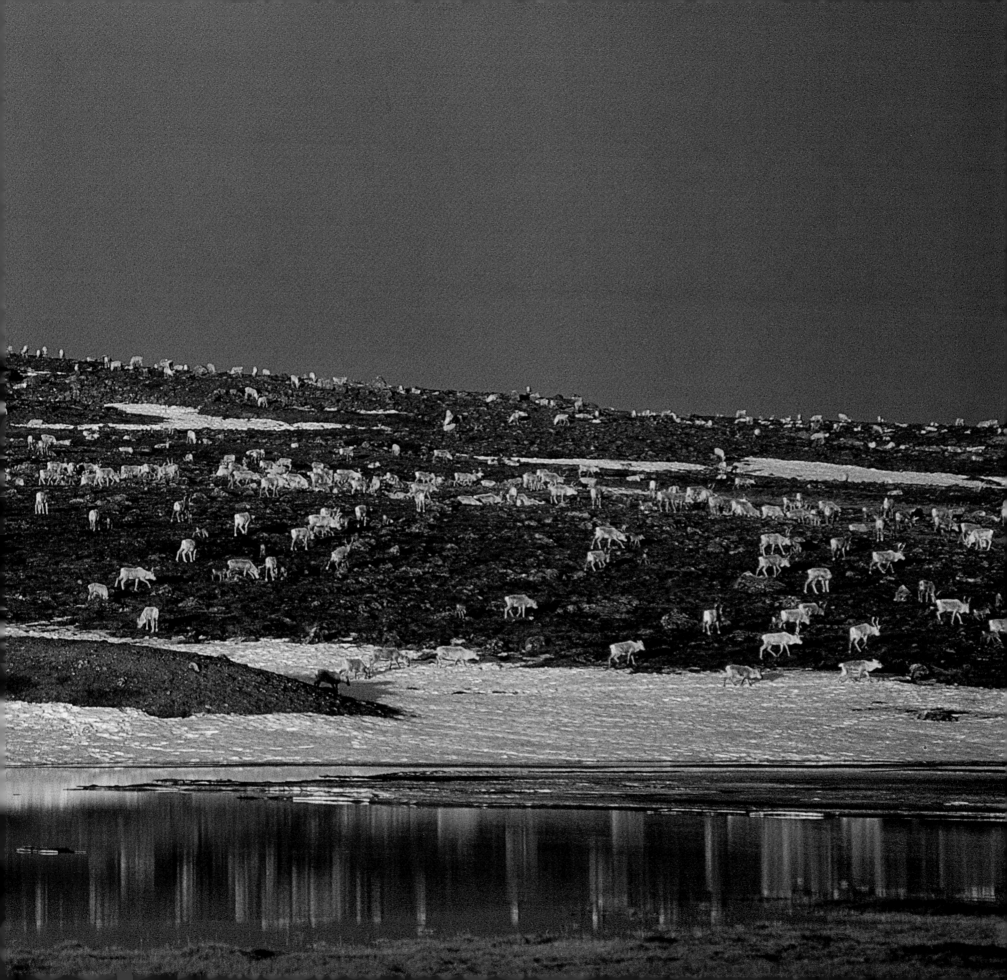

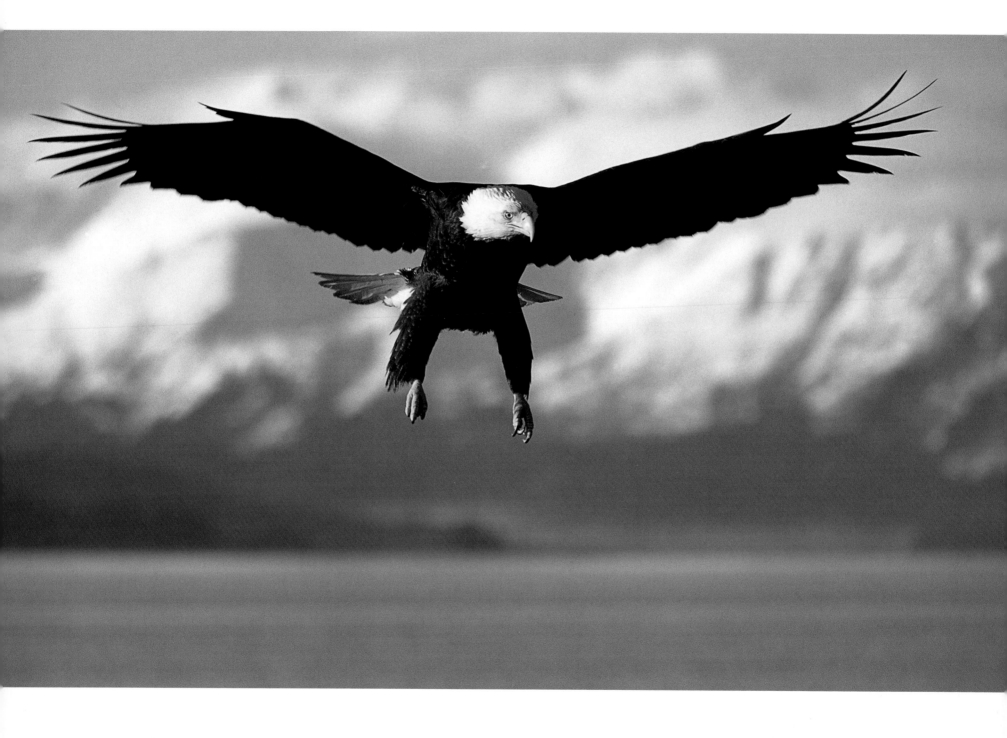

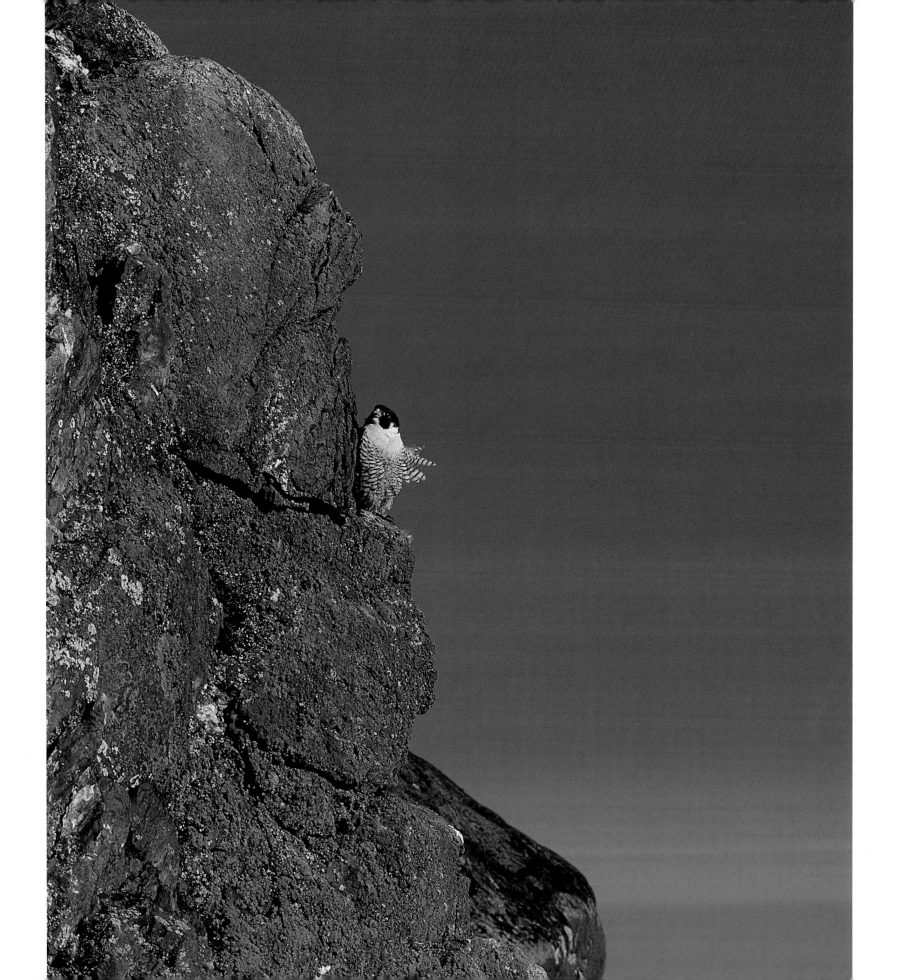

PAGES 20–21 *As far as the eye can see, thousands of caribou cows and their newborn calves litter the Barren Grounds of the central Arctic.*

PAGE 22 *A bald eagle descends along the shores of southeast Alaska.*

PAGE 23 *A peregrine falcon blends in with these lichen-covered cliffs, where it can be on the lookout for prey.*

ABOVE *Unlike fireweed in the south, dwarf fireweed hugs the ground to protect itself from the strong winds of the Arctic.*

RIGHT *A juvenile arctic hare feeds on spring flowers.*

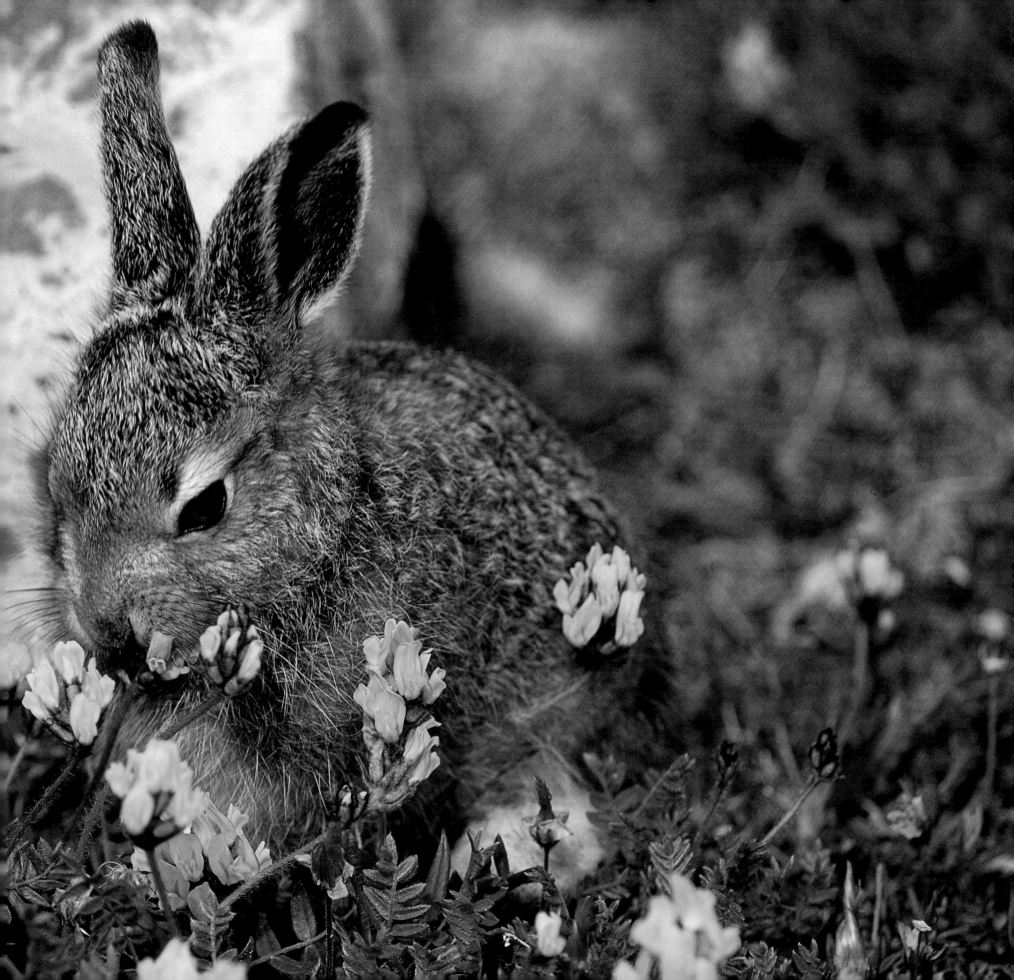

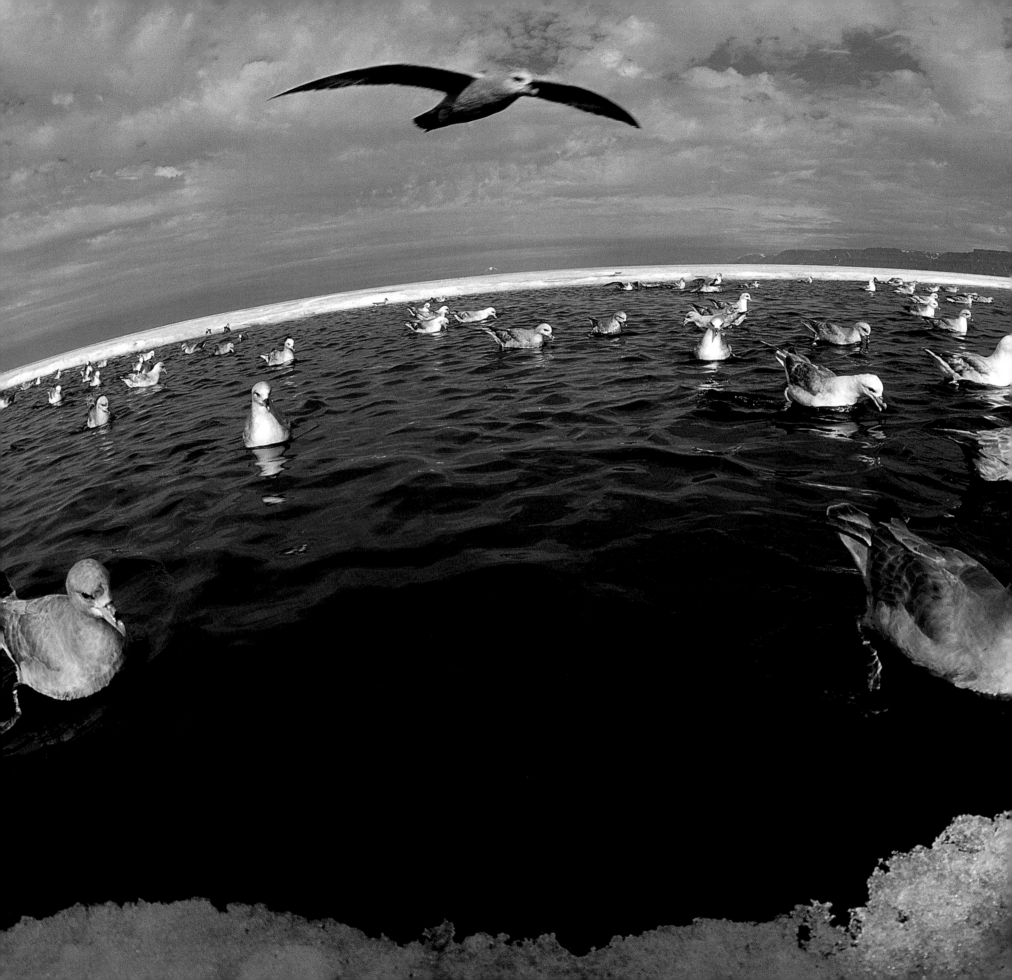

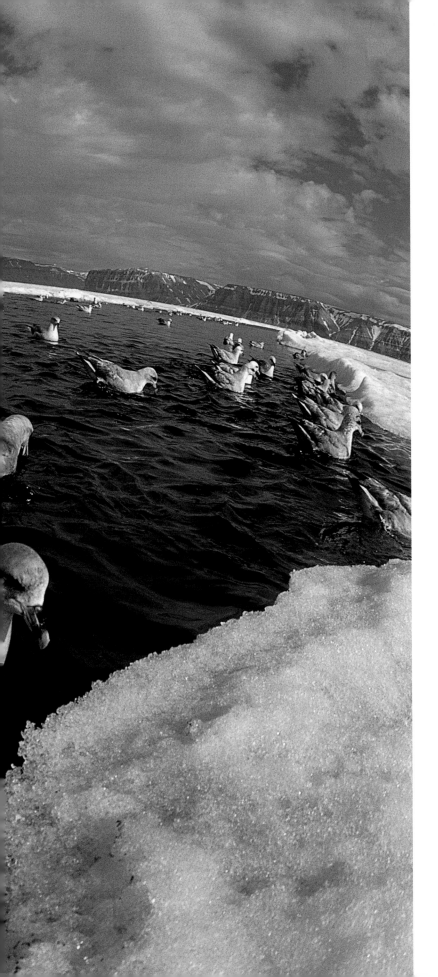

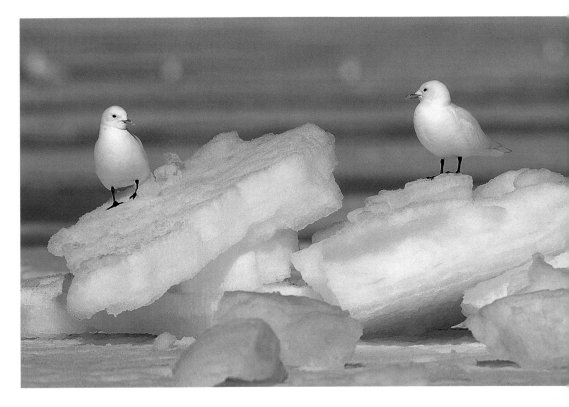

LEFT *Northern fulmars flock to newly formed cracks in the sea ice to feast on the ocean's bounty.*

ABOVE *Ivory gulls perch on chunks of sea ice as it breaks up around them.*

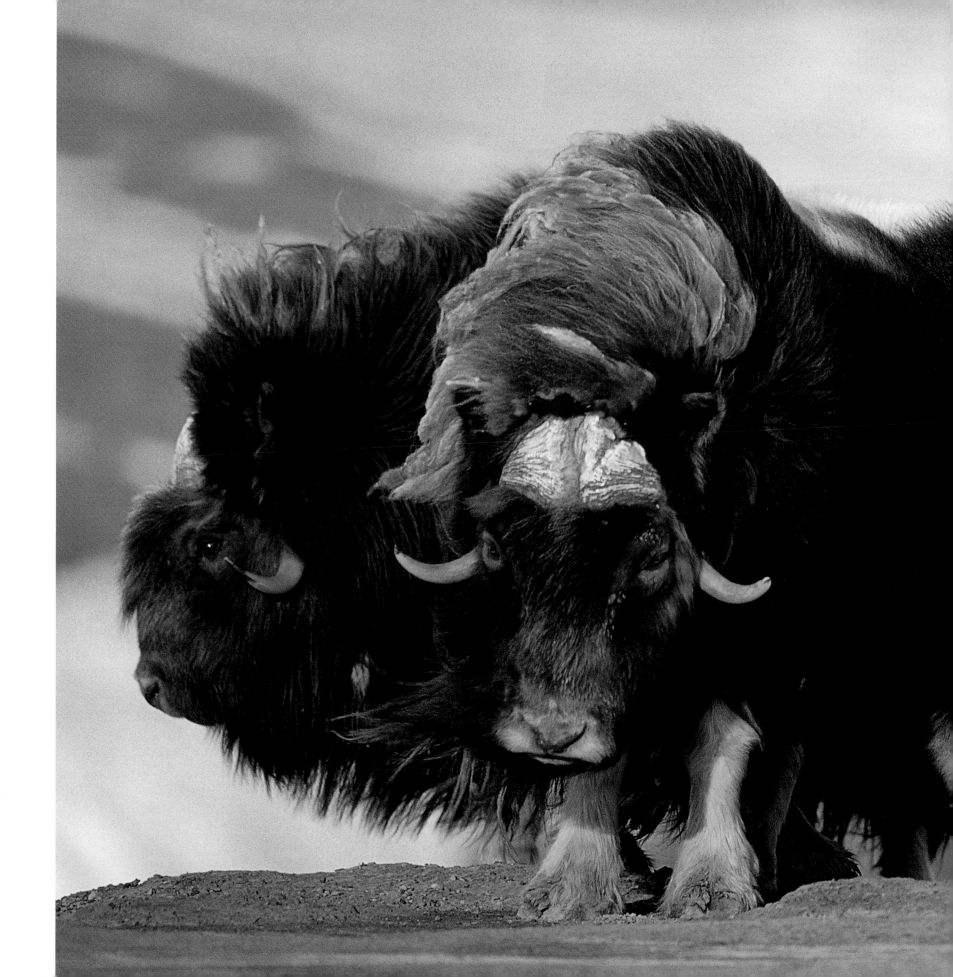

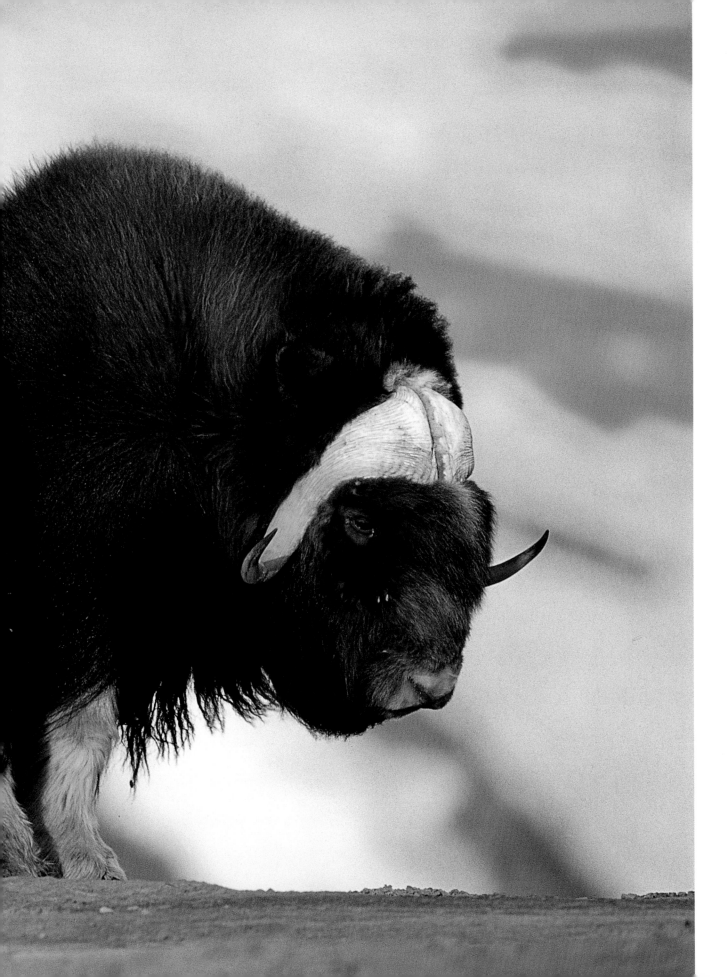

On Ellesmere Island an imposing trio of muskoxen forms a defense ring, an effective deterrent against their primary predator—the arctic wolf.

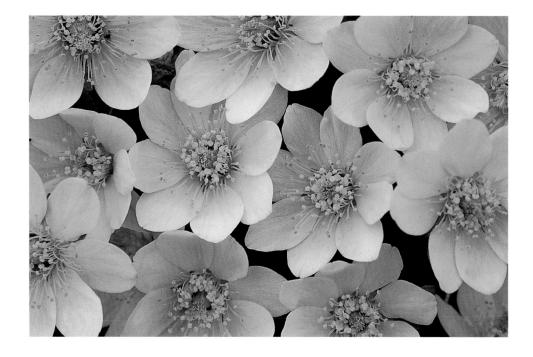

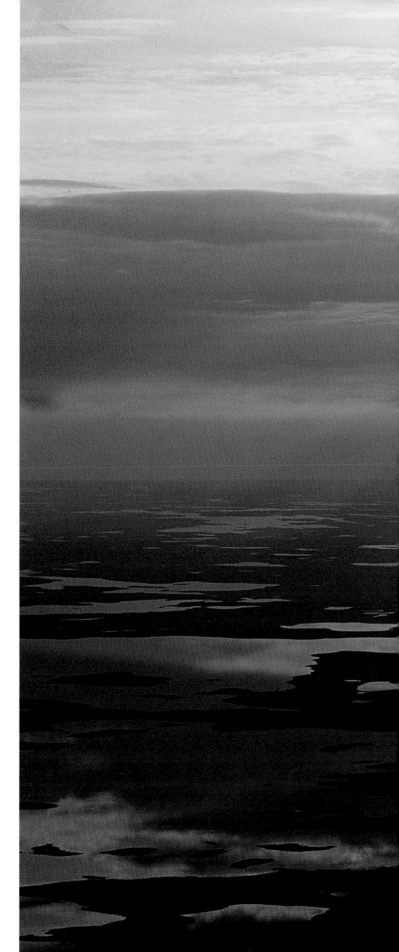

ABOVE *Cream-colored mountain avens announce the arrival of summer in the Arctic.*

RIGHT *A meshwork of countless lakes clutters the central Barren Grounds, between Great Slave Lake and Great Bear Lake, making it a challenging route for caribou and other wildlife to navigate.*

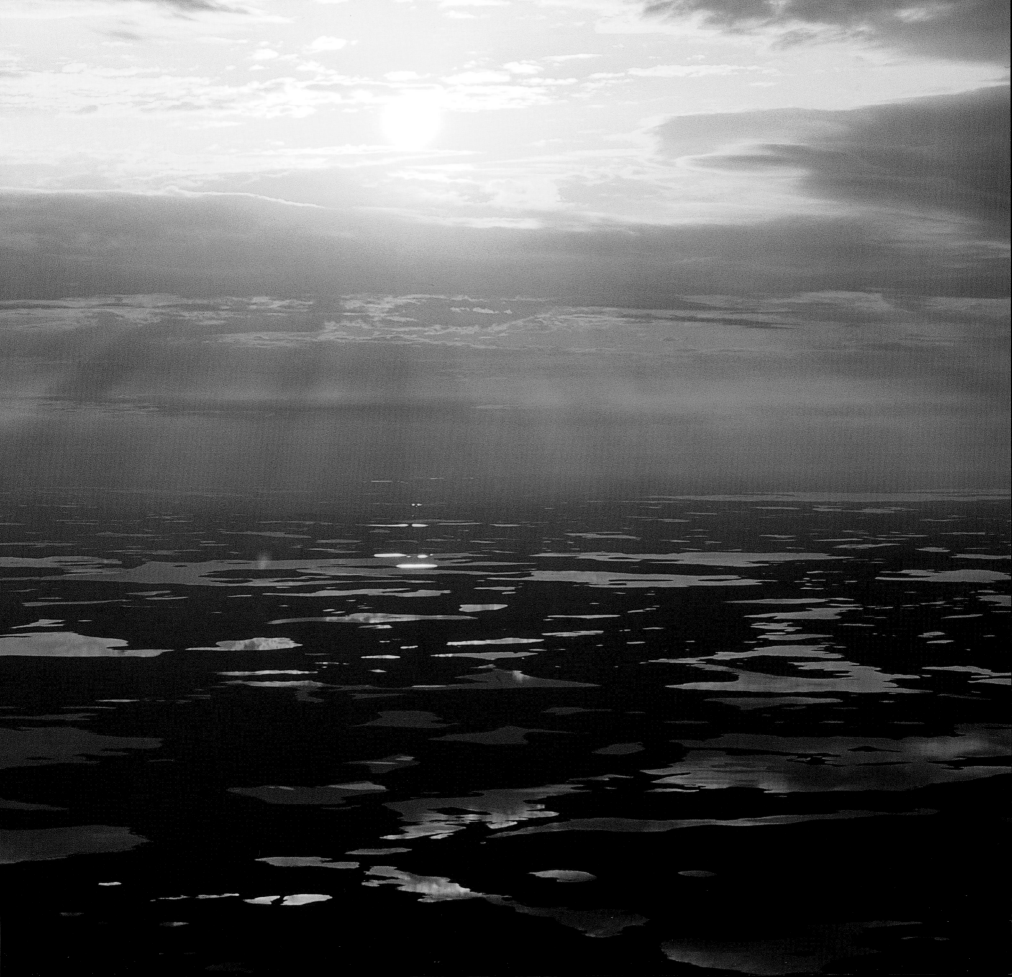

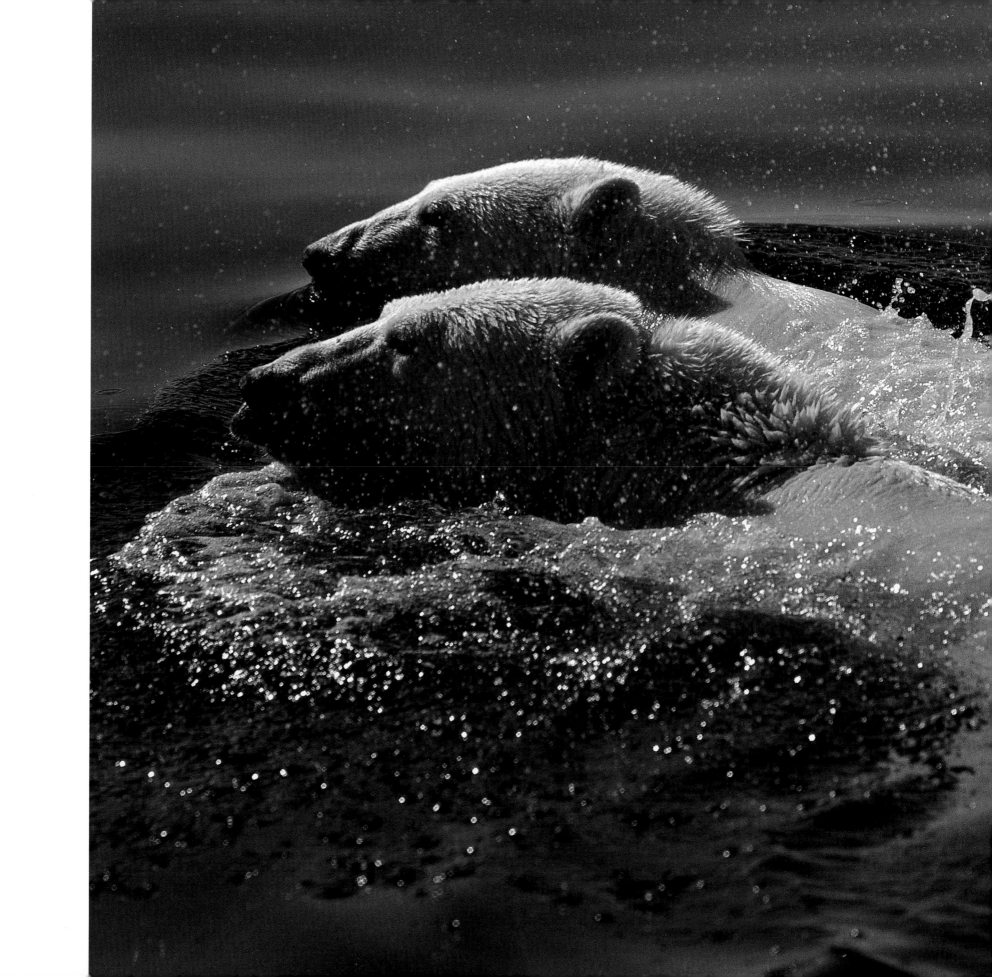

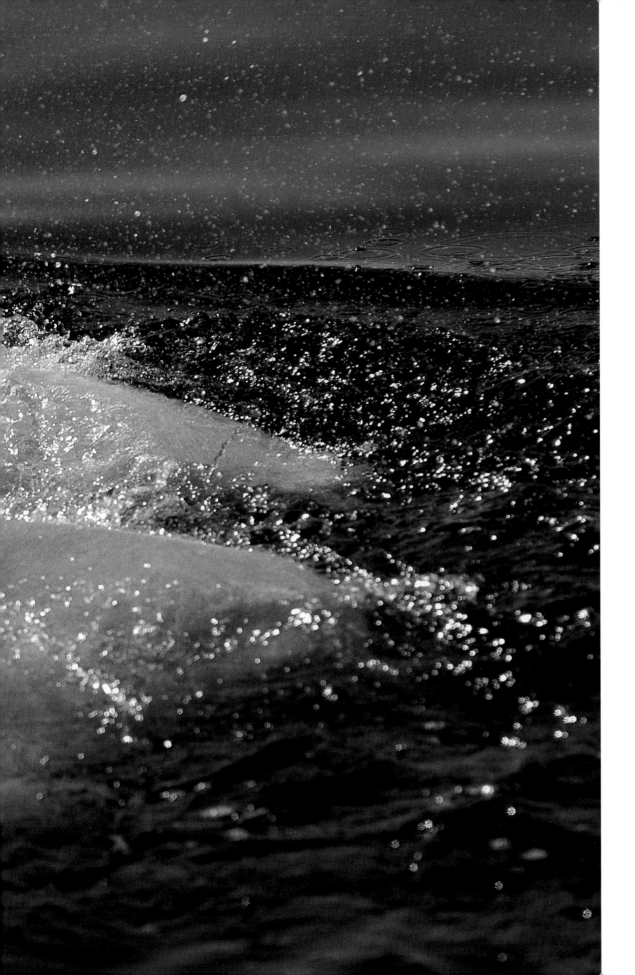

A mother and her two-year-old cub
ply the frigid seas of the Arctic Ocean
off the shores of Baffin Island. Polar
bears are strong swimmers but rarely
swim farther than to land or ice that
they can see.

3 3

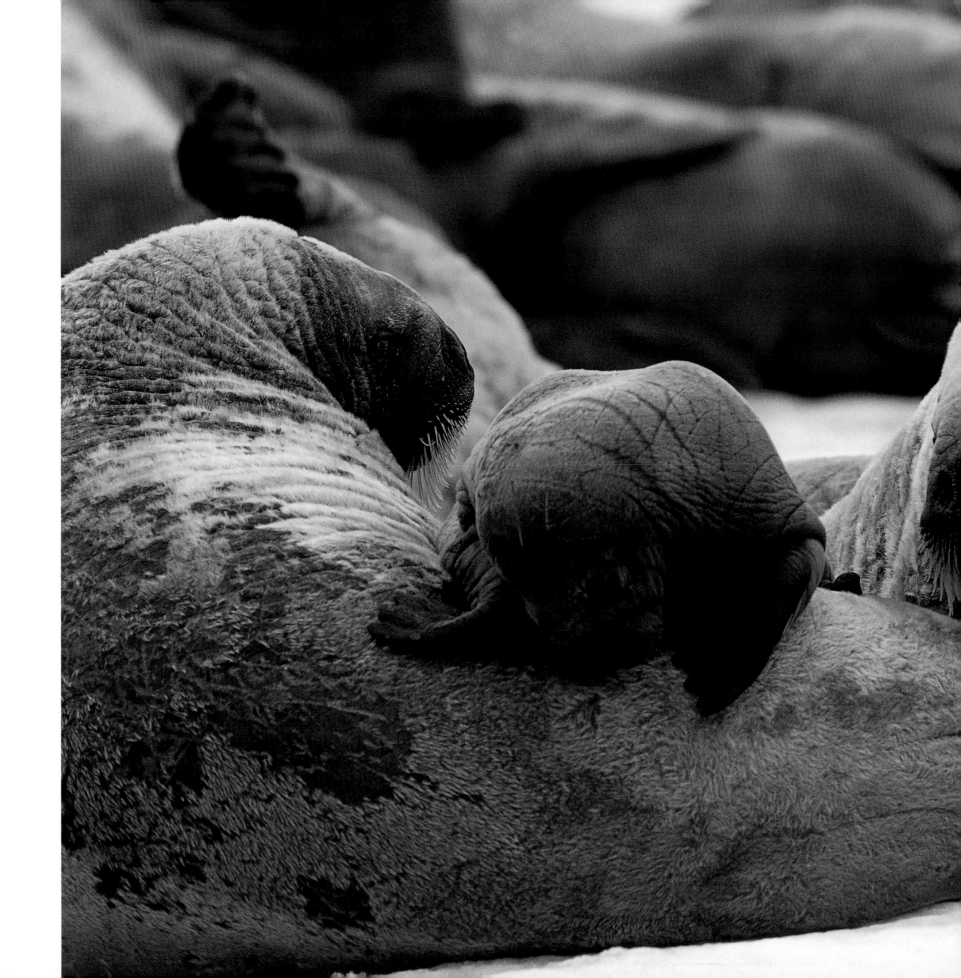

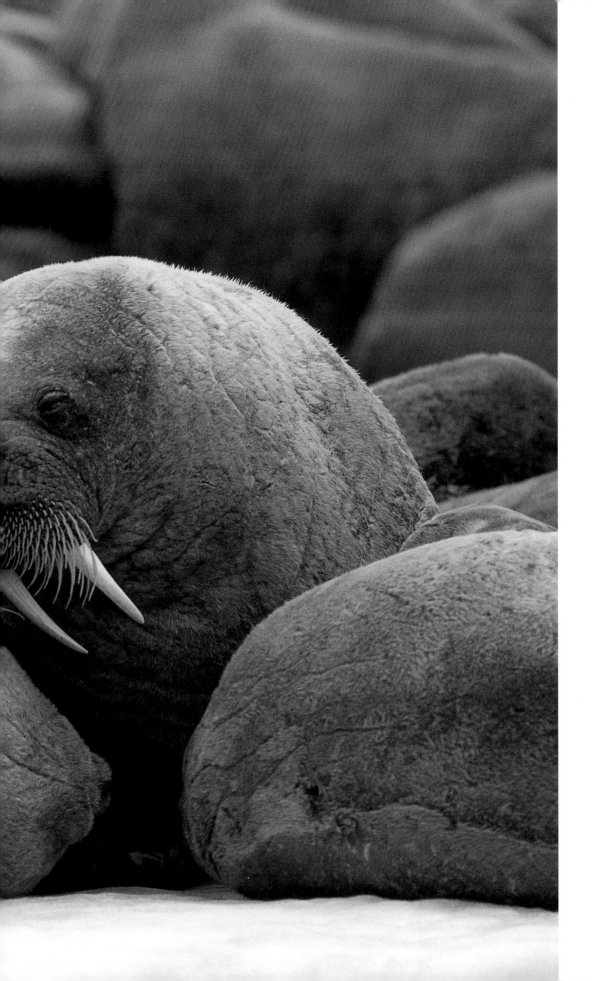

In a group of more than two hundred walruses in Foxe Basin, a pup seeks refuge on its mother's back.

3 5

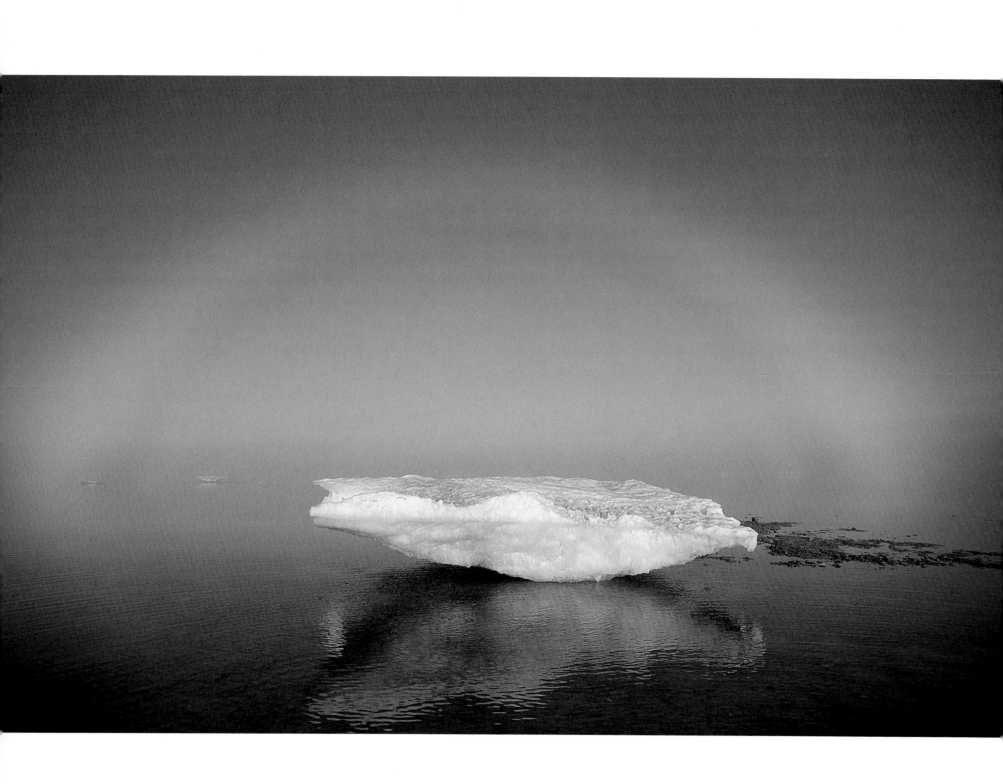

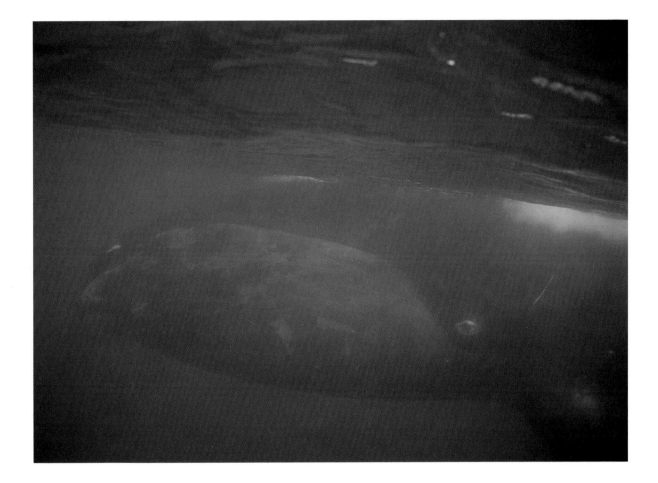

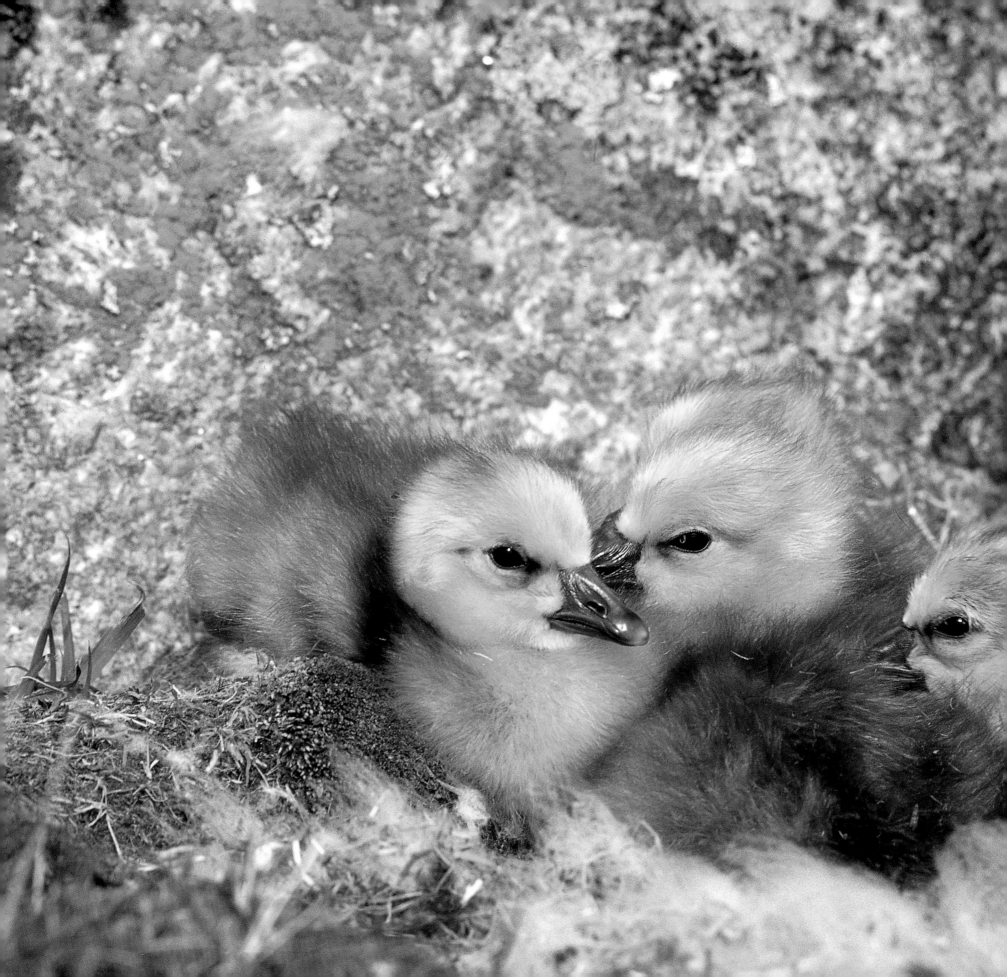

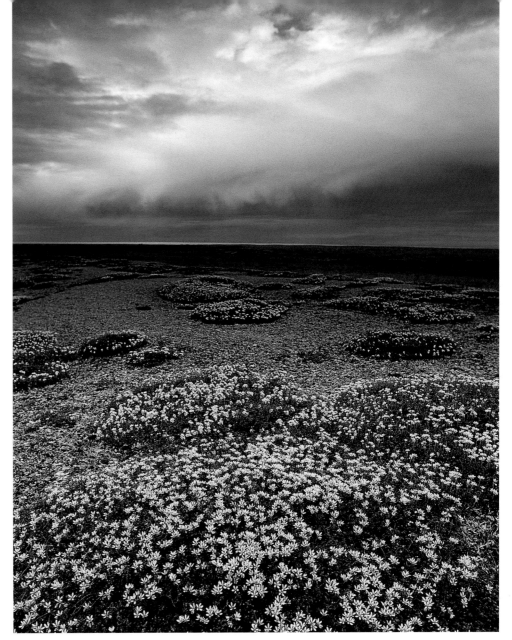

LEFT *Downy snow-goose chicks bask in the warmth of a sunny summer day in the High Arctic.*

ABOVE *Arctic flowers can grow almost anywhere. Here spotted saxifrage bloom on a raised gravel beach.*

39

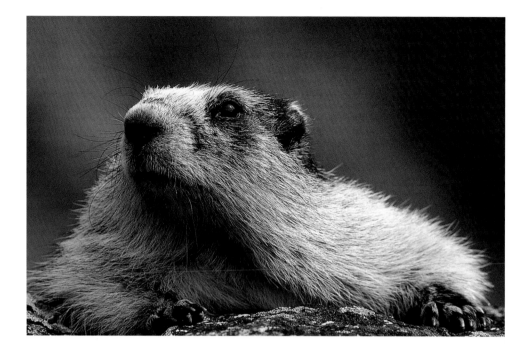

ABOVE *A plump hoary marmot keeps a watchful eye out for a golden eagle or a grizzly bear from its mountainside watchtower.*

RIGHT *A tundra wolf is awakened from a summer nap in a bed of purple lupine.*

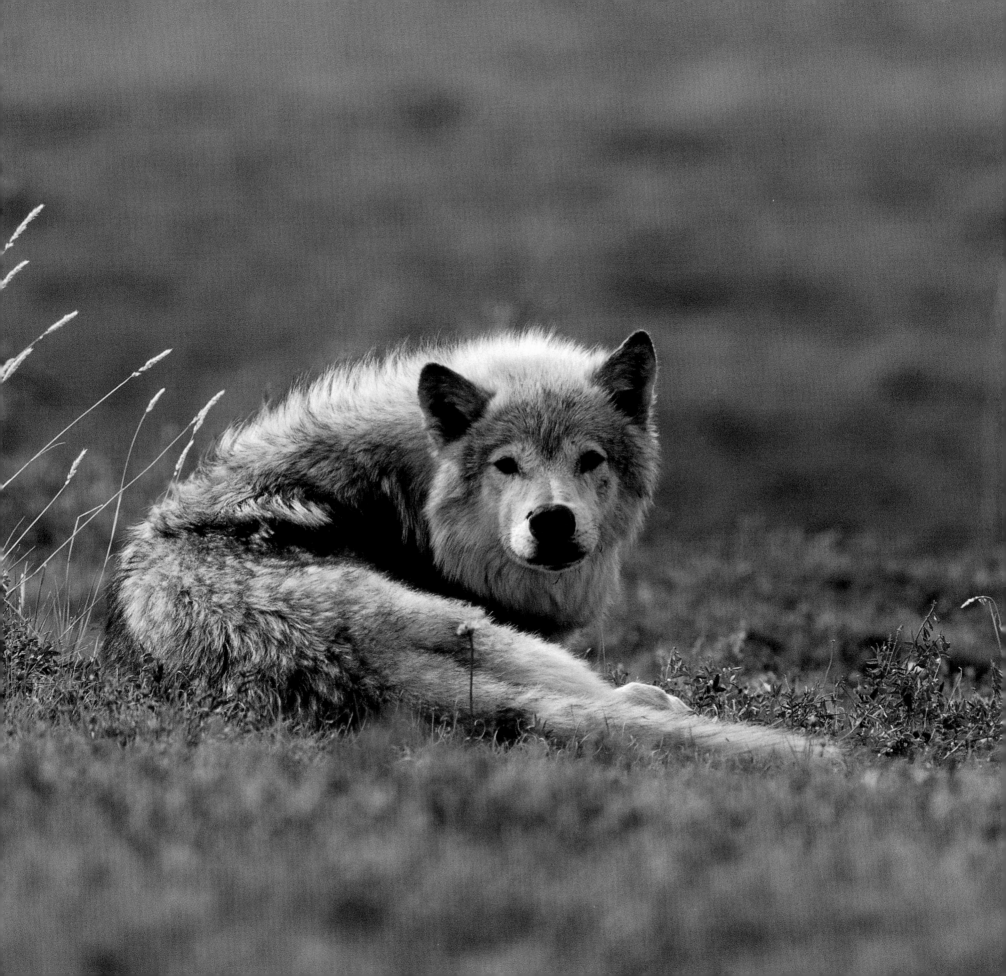

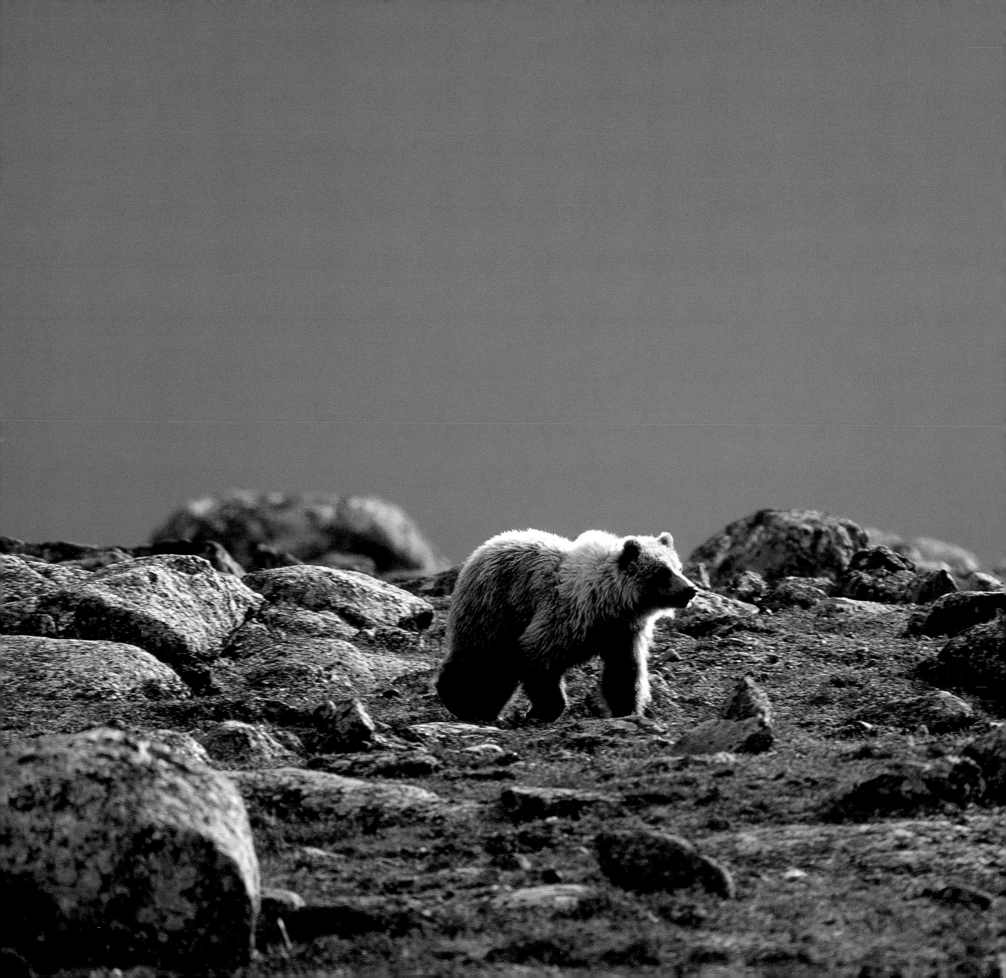

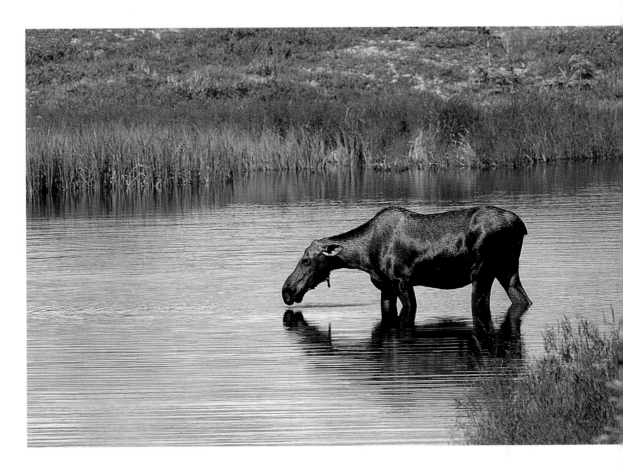

LEFT *This Barren Grounds grizzly bear cruises the tundra in search of an arctic ground squirrel or a wounded caribou.*

ABOVE *A cow finds its nutrients on the bottom of a pond in Yukon.*

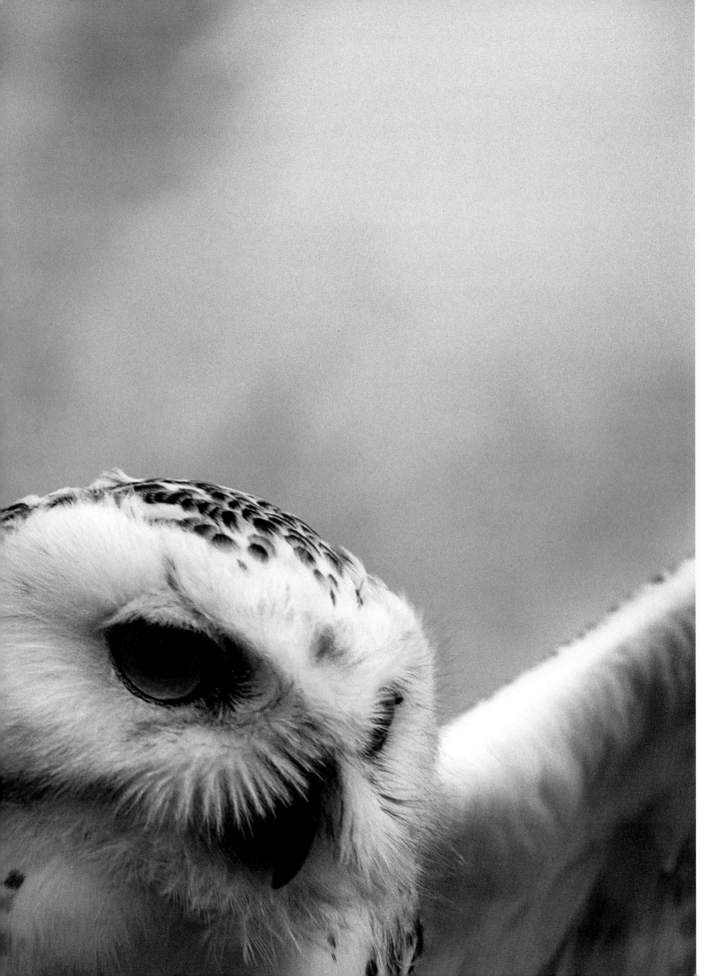

*A magnificent snowy owl takes off,
flying over the camera.*

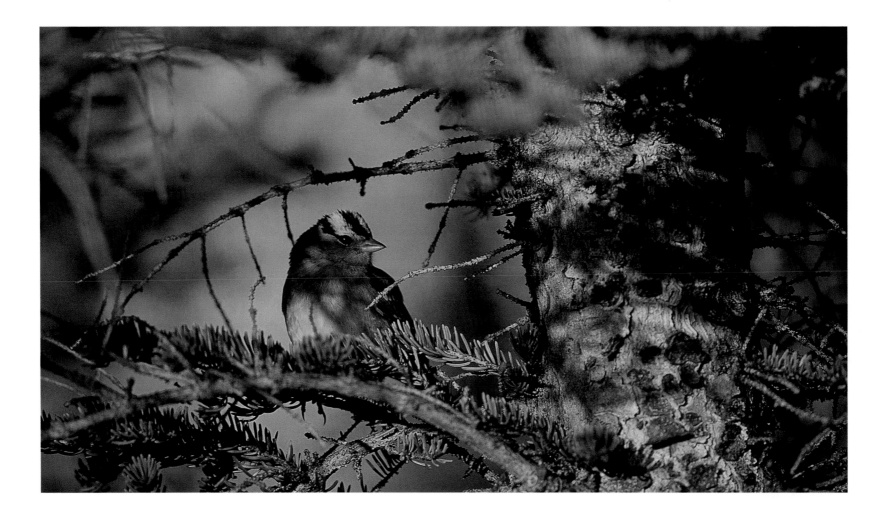

ABOVE *Bathed in light from the summer's midnight sun, a white-crowned sparrow rests as evening temperatures approach freezing well above the Arctic Circle.*

FACING PAGE *A willow ptarmigan in its earth-colored summer plumage takes a sand bath to rid itself of parasites.*

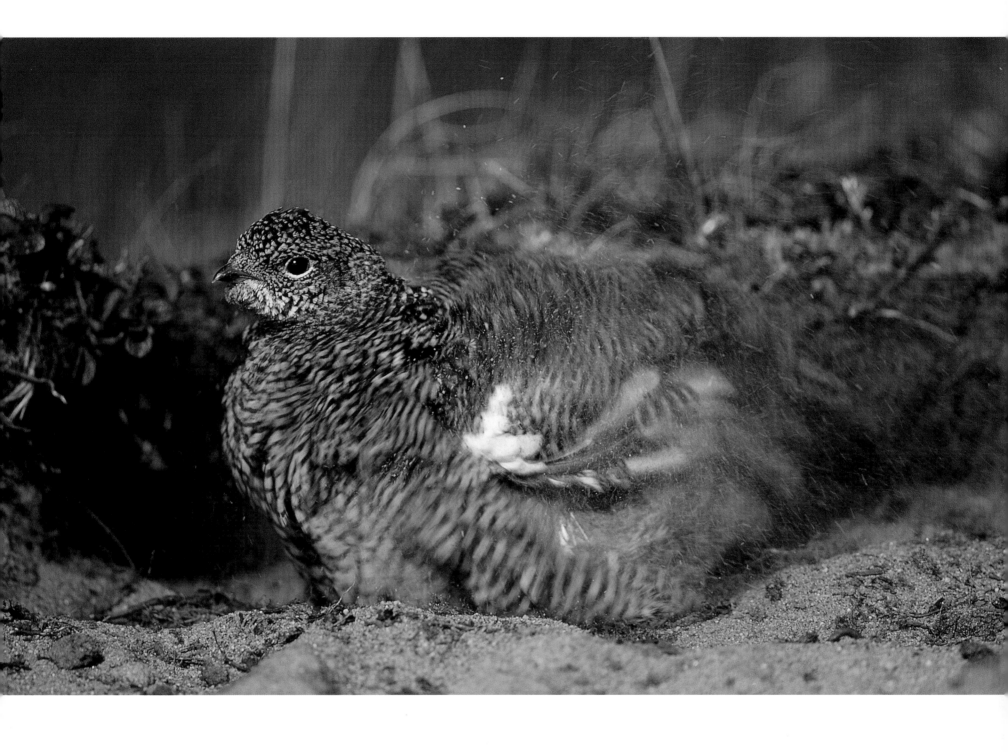

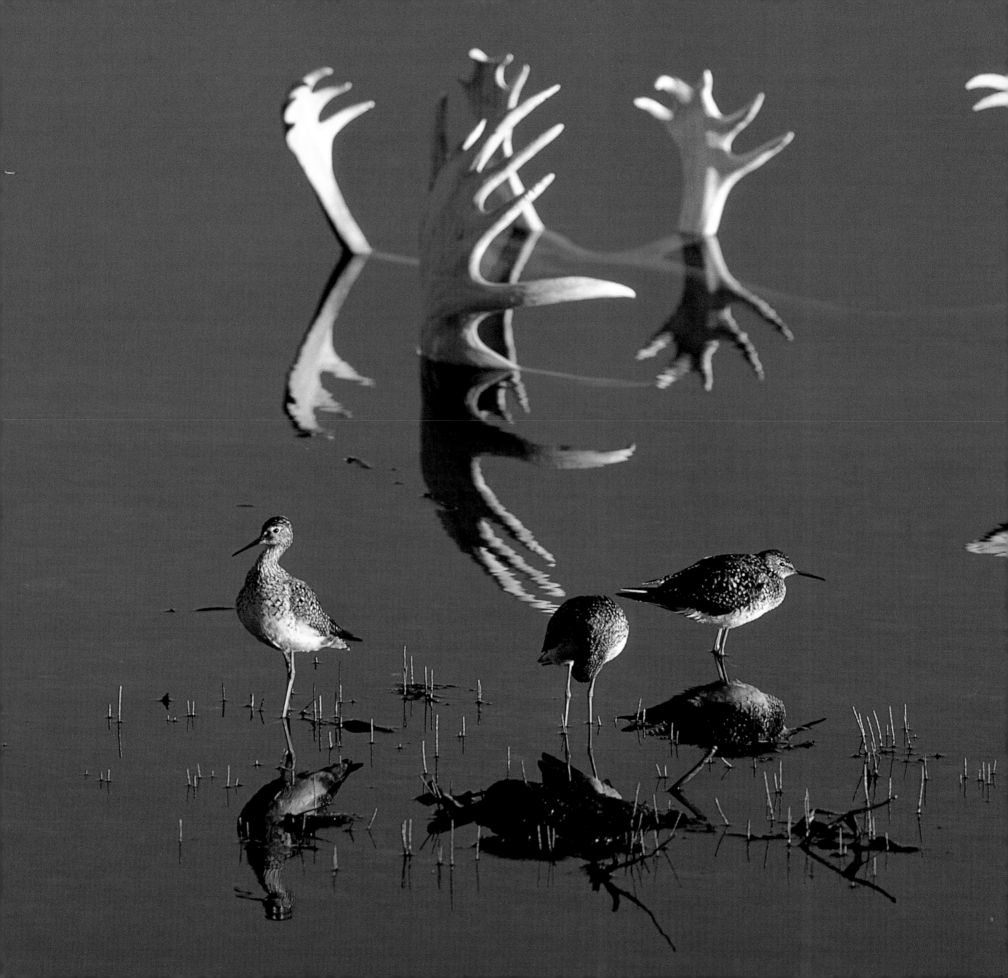

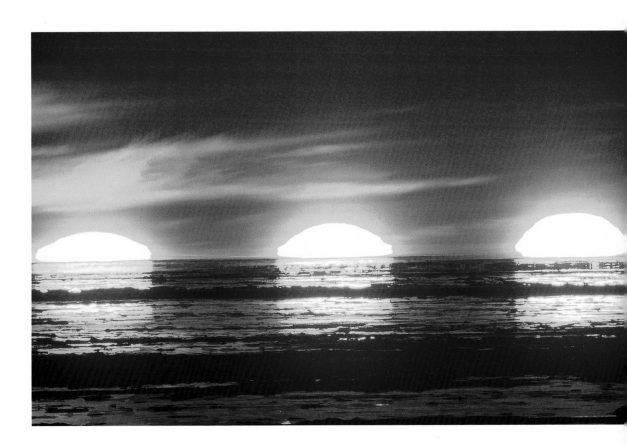

LEFT *Against an eerie tableau of caribou antlers, three lesser yellowlegs preen themselves in the Horton River at 2:00 A.M. Because the antlers are intact, the caribou most likely fell victim to predation the previous fall.*

ABOVE *In this multiple-exposure shot, the sun skips across the horizon in an endless sunset over the sea surrounding Igloolik. Although this shot was taken five weeks after the summer solstice, the sun still does not drop below the horizon.*

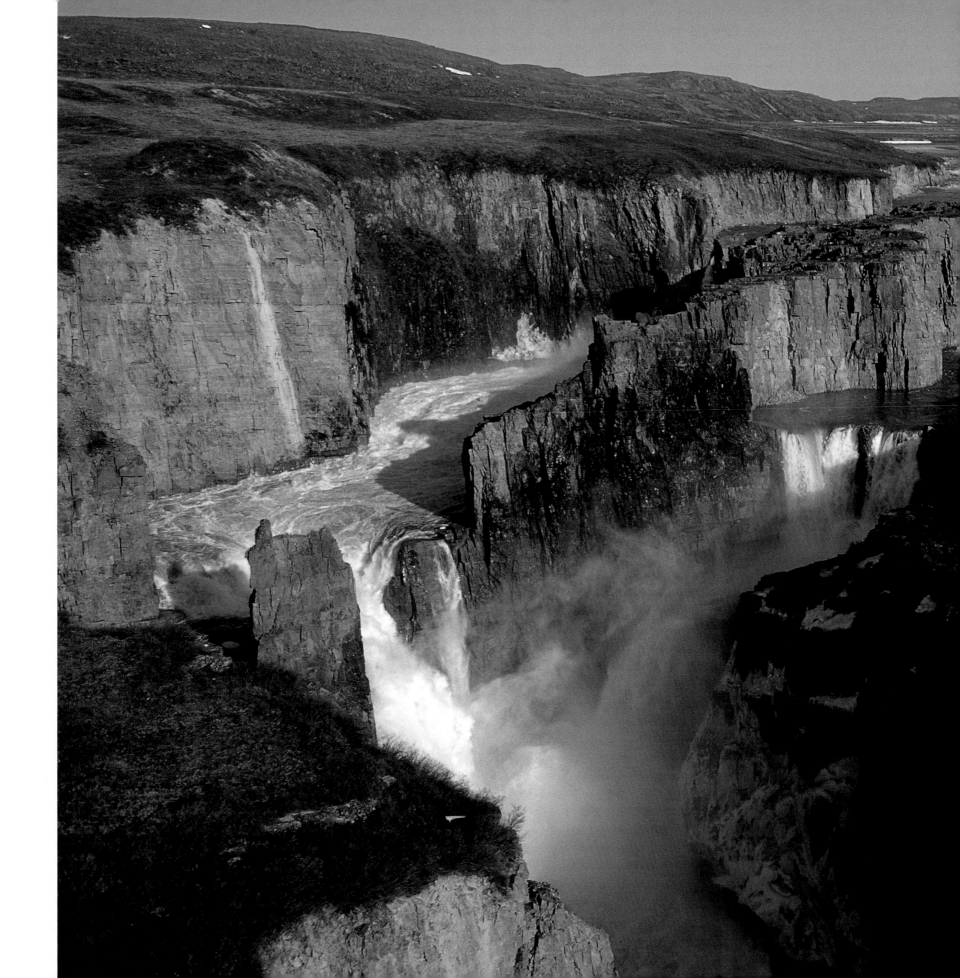

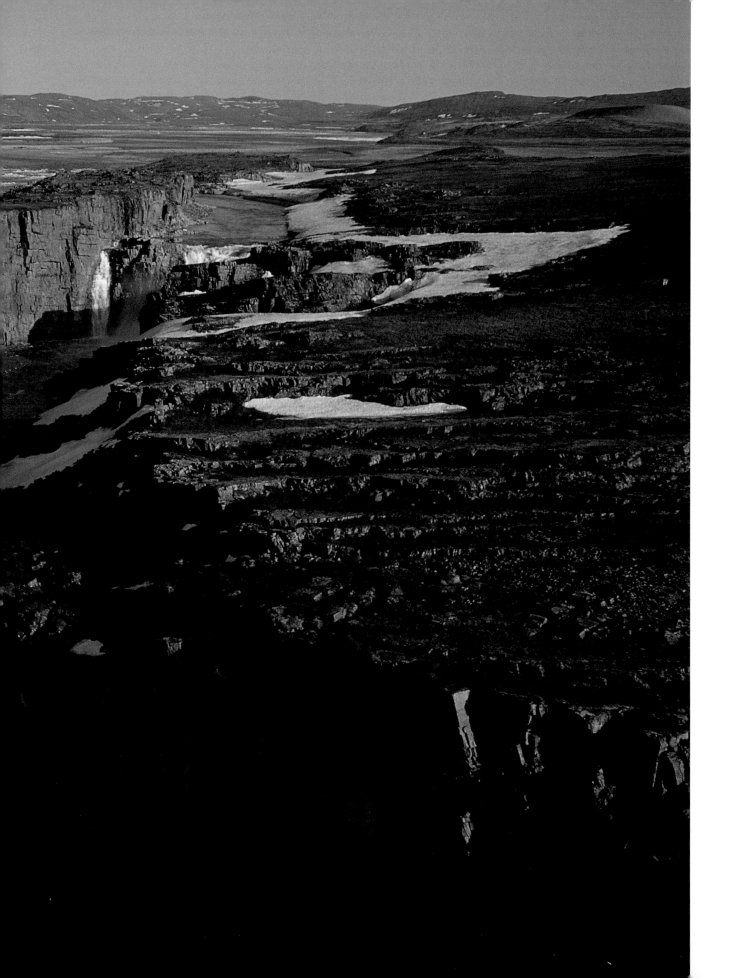

The towering Wilberforce Falls on the Hood River are at their peak level after heavy snow and ice melt.

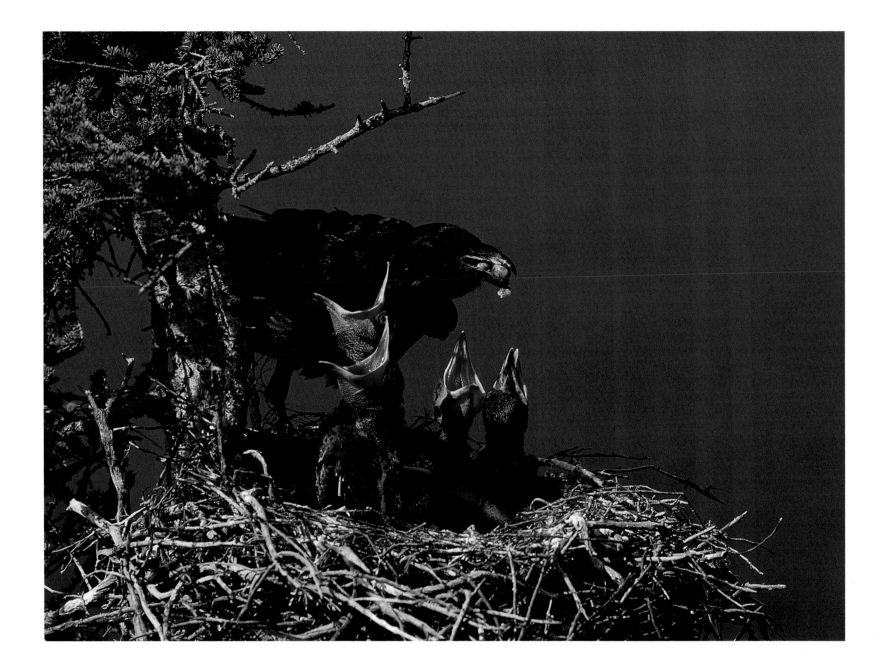

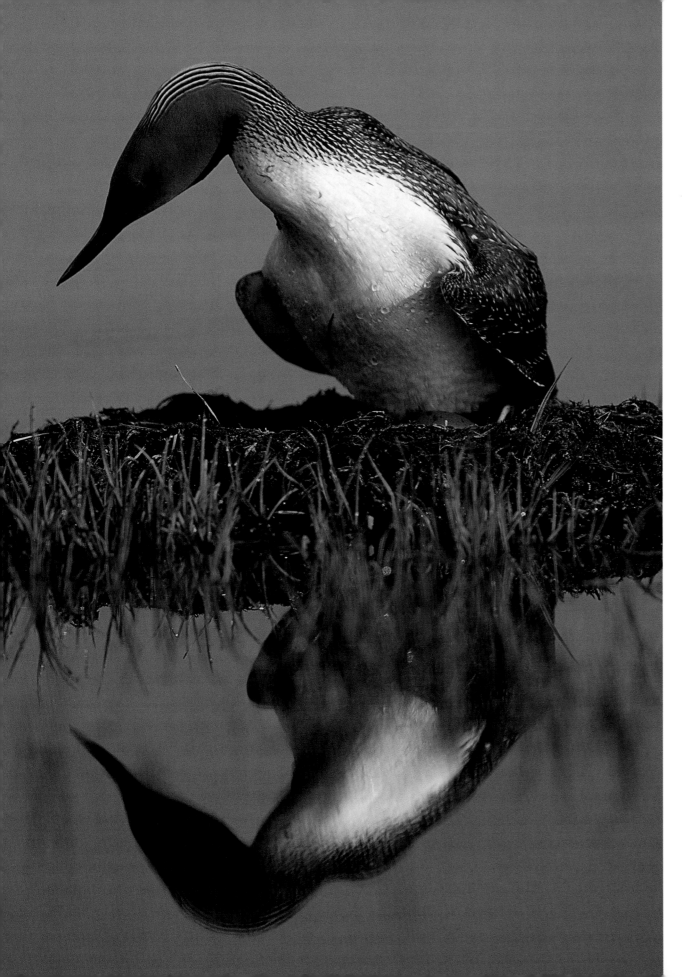

FACING PAGE *A raven feeds her hungry chicks eggs found in another nest.*

LEFT *A red-throated loon is reflected in a small tundra pond as it rotates its egg on its nest. The loon's mate is off catching prey in the nearby Arctic Ocean.*

5 3

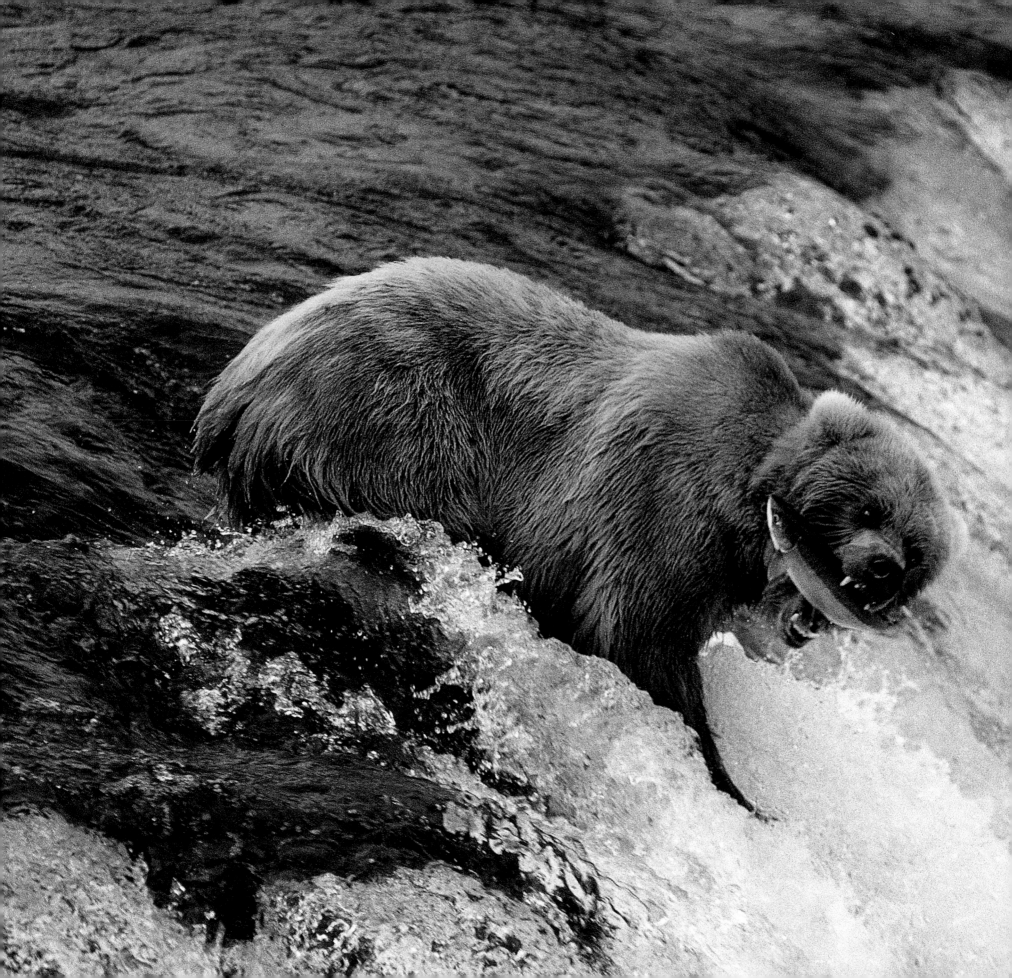

*An agile grizzly snatches a leaping
salmon out of the air at Brooks Falls
in Alaska.*

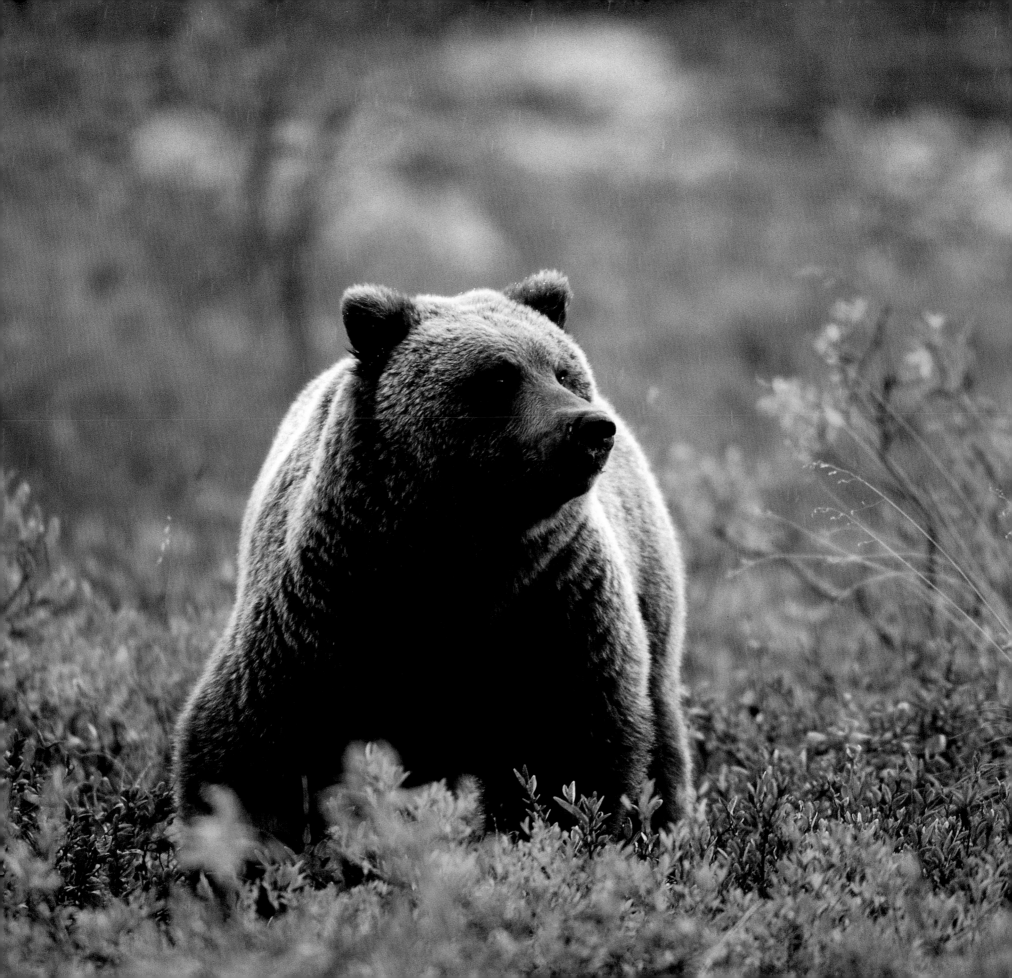

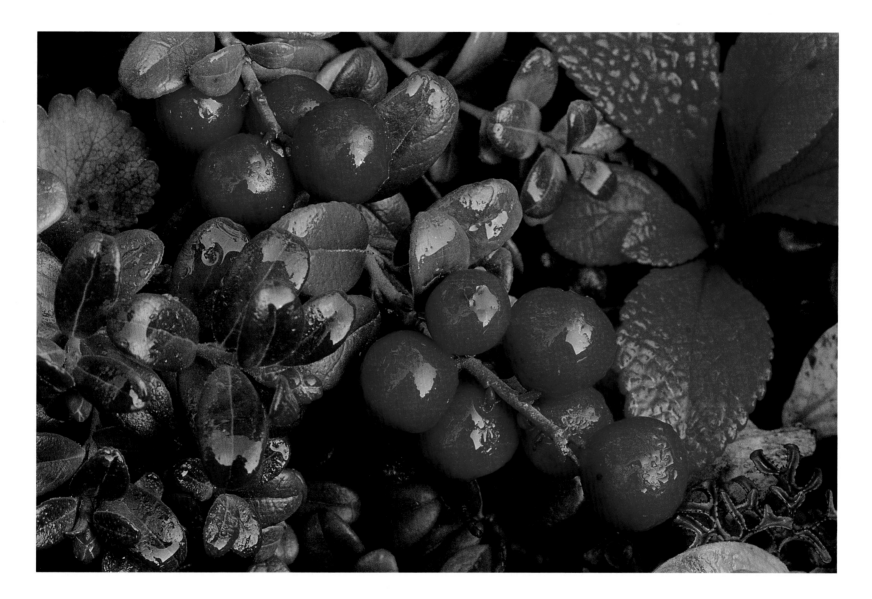

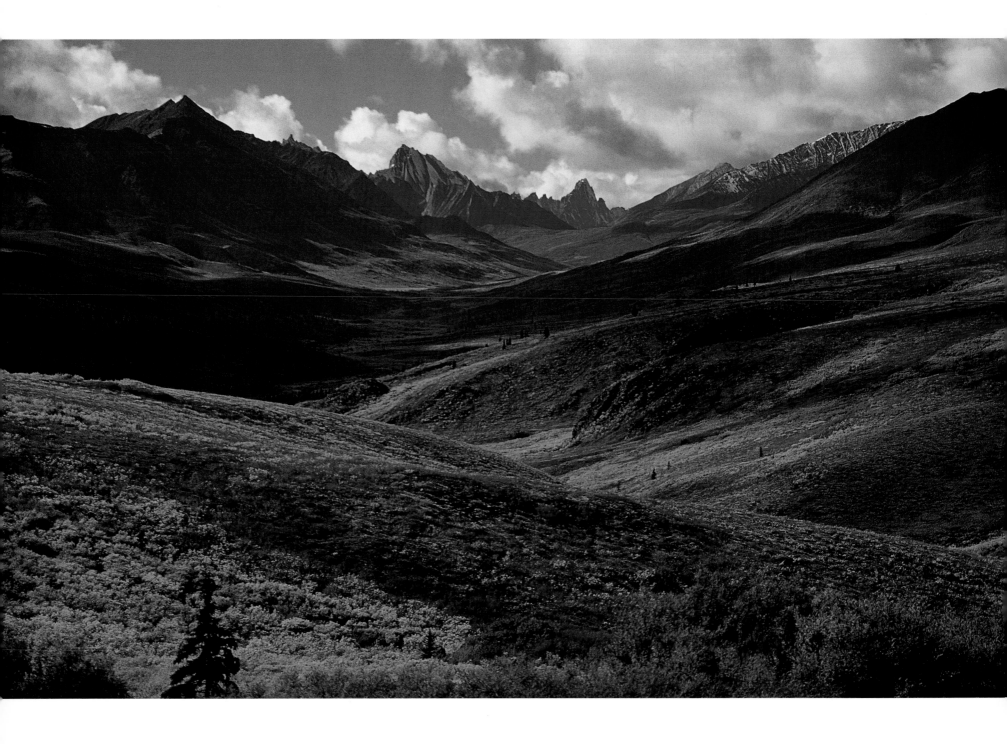

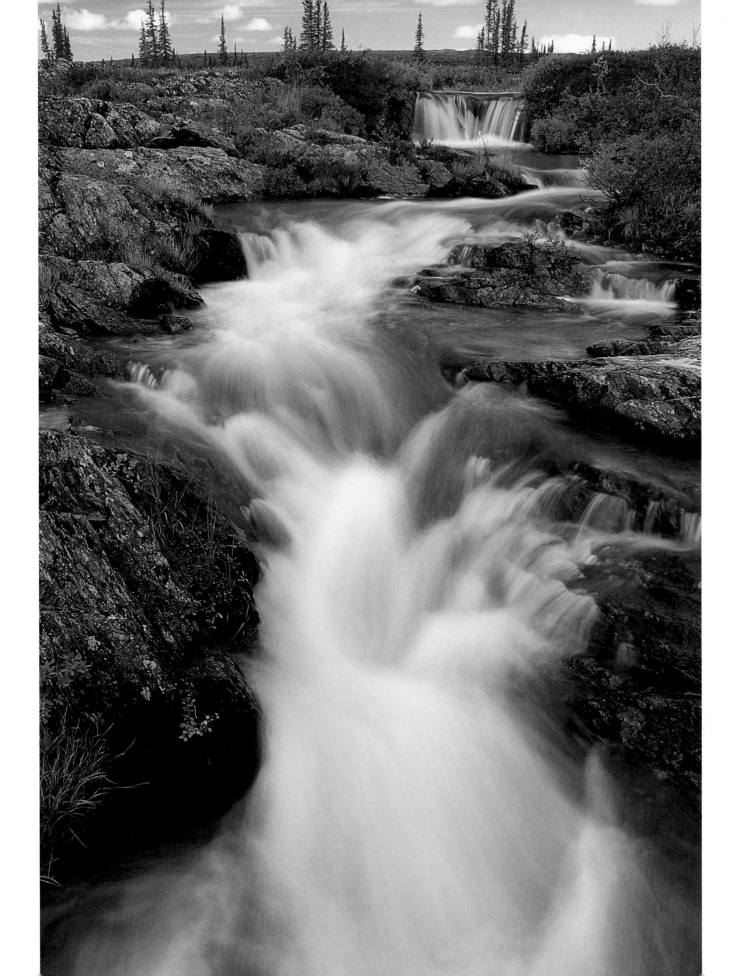

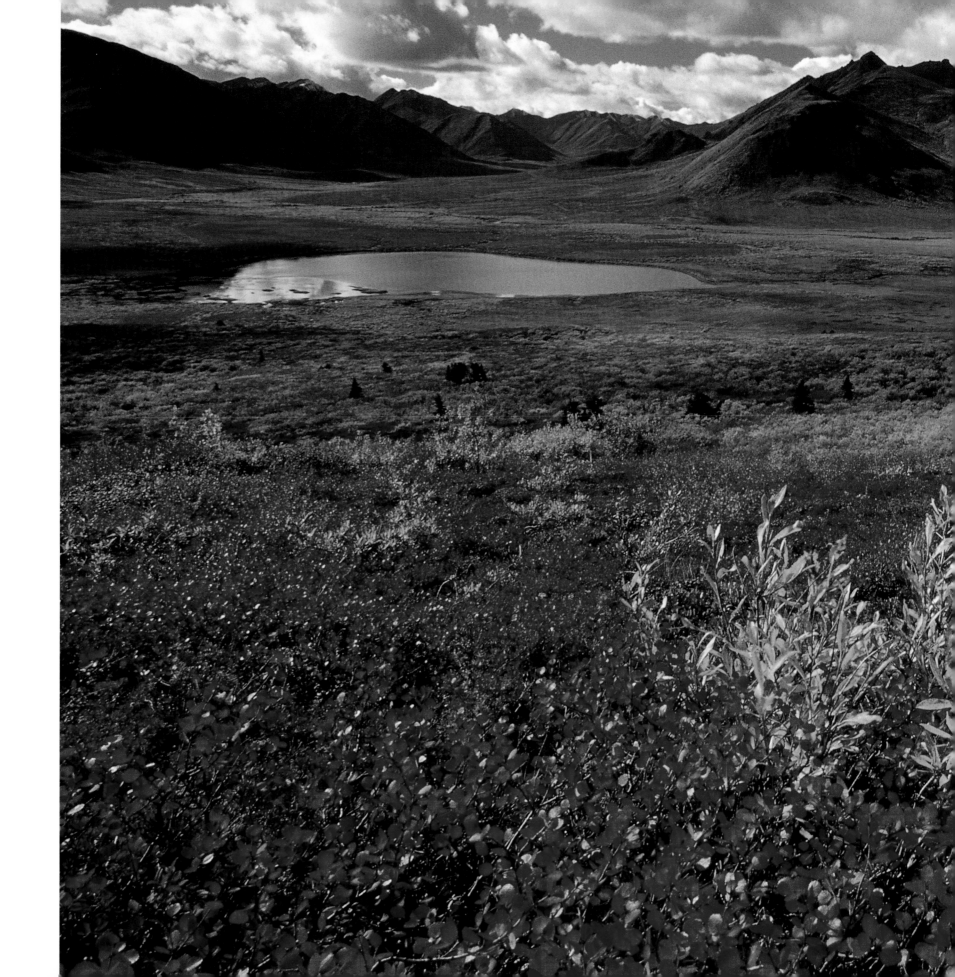

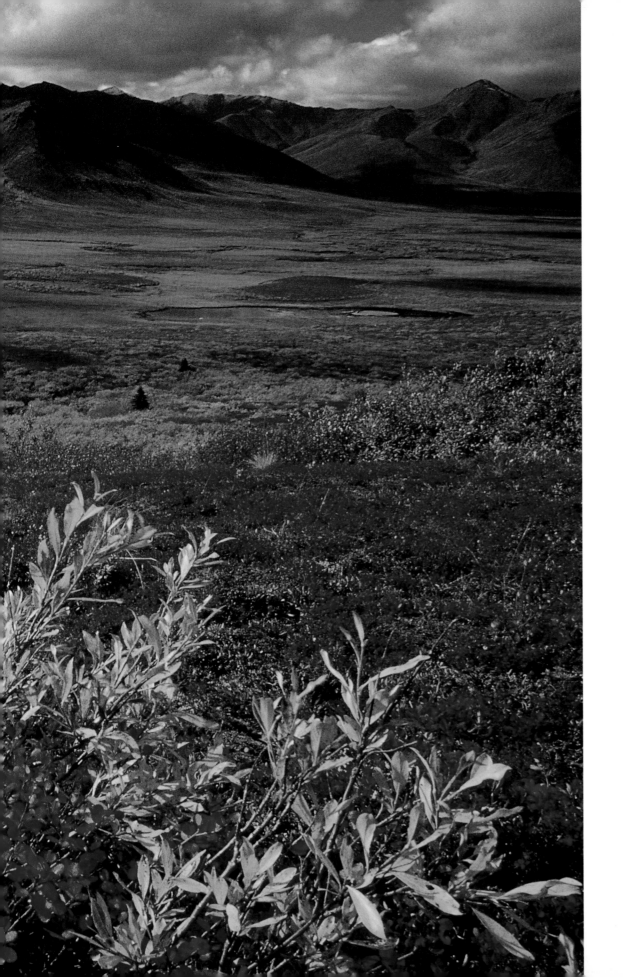

PAGE 58 *Brilliant fall colors sweep around the barren Tombstone Mountains.*

PAGE 59 *A river pours over ancient bedrock on the central barrens of Canada's Arctic. Sparse trees indicate small pockets of taiga where the forest meets the barrens.*

LEFT *As winter approaches and nights become cooler in the Ogilvie Mountains, the tundra is transformed into a blanket of reds and yellows.*

6 1

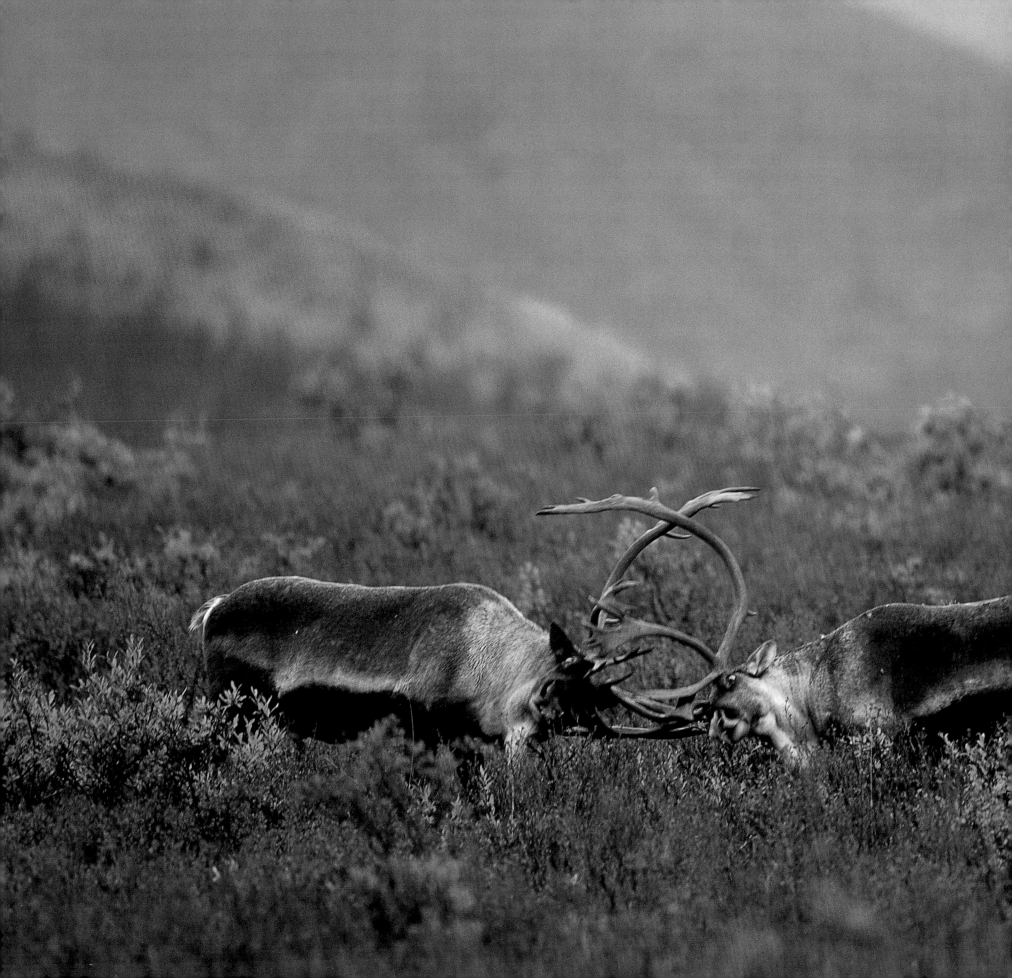

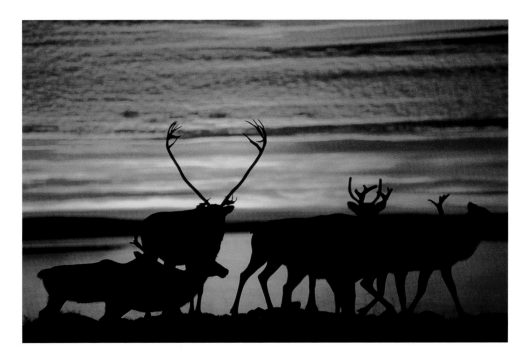

LEFT *Two male caribou practice sparring against a backdrop of russet-colored vegetation. This is a prelude to the real sparring they will do in another month.*

ABOVE *After a summer of gorging themselves on the open tundra, caribou bulls, cows, and calves of the Bathurst herd head toward the shelter of the forest, hundreds of miles to the south.*

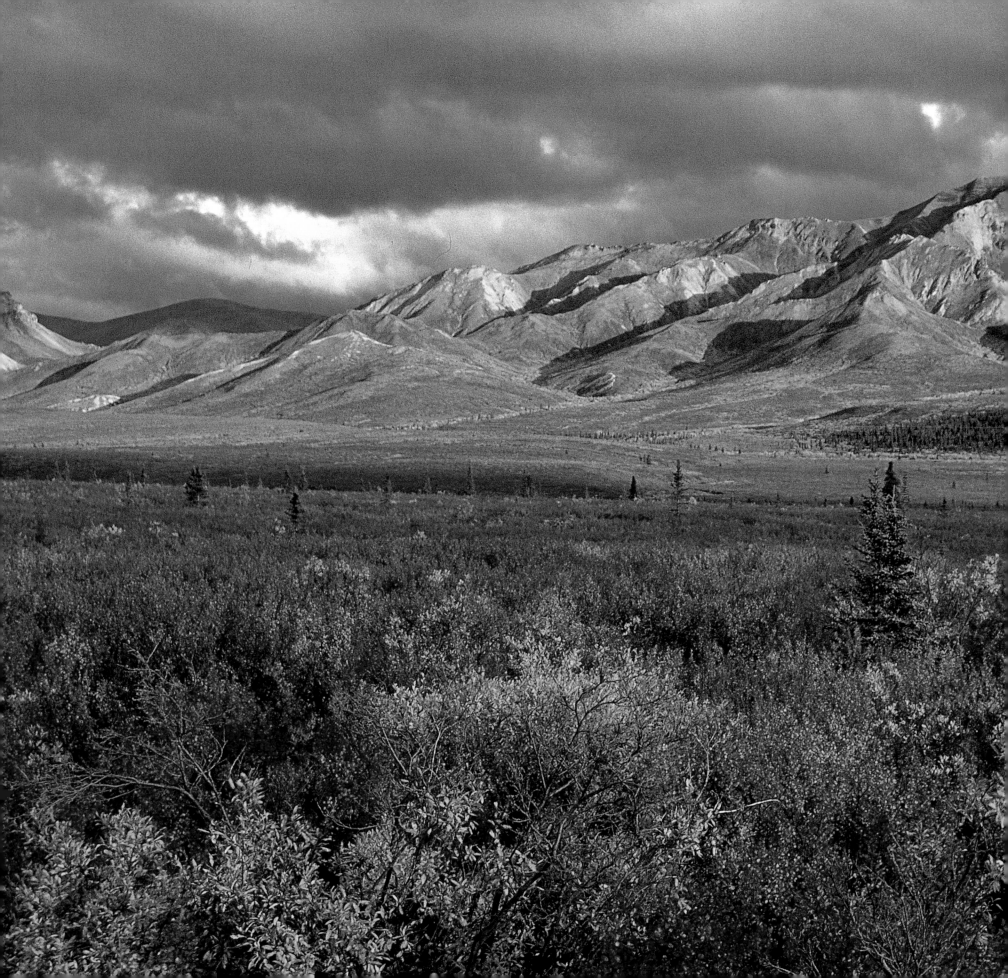

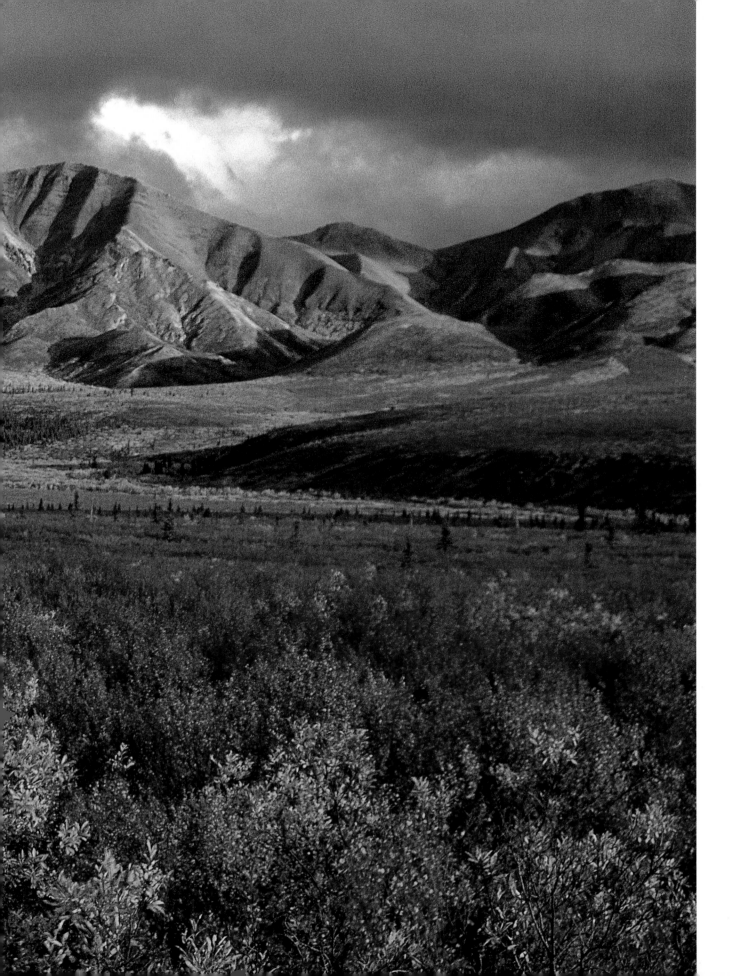

Willow bushes and other vegetation color the landscape with their rich hues beneath an autumnal sky.

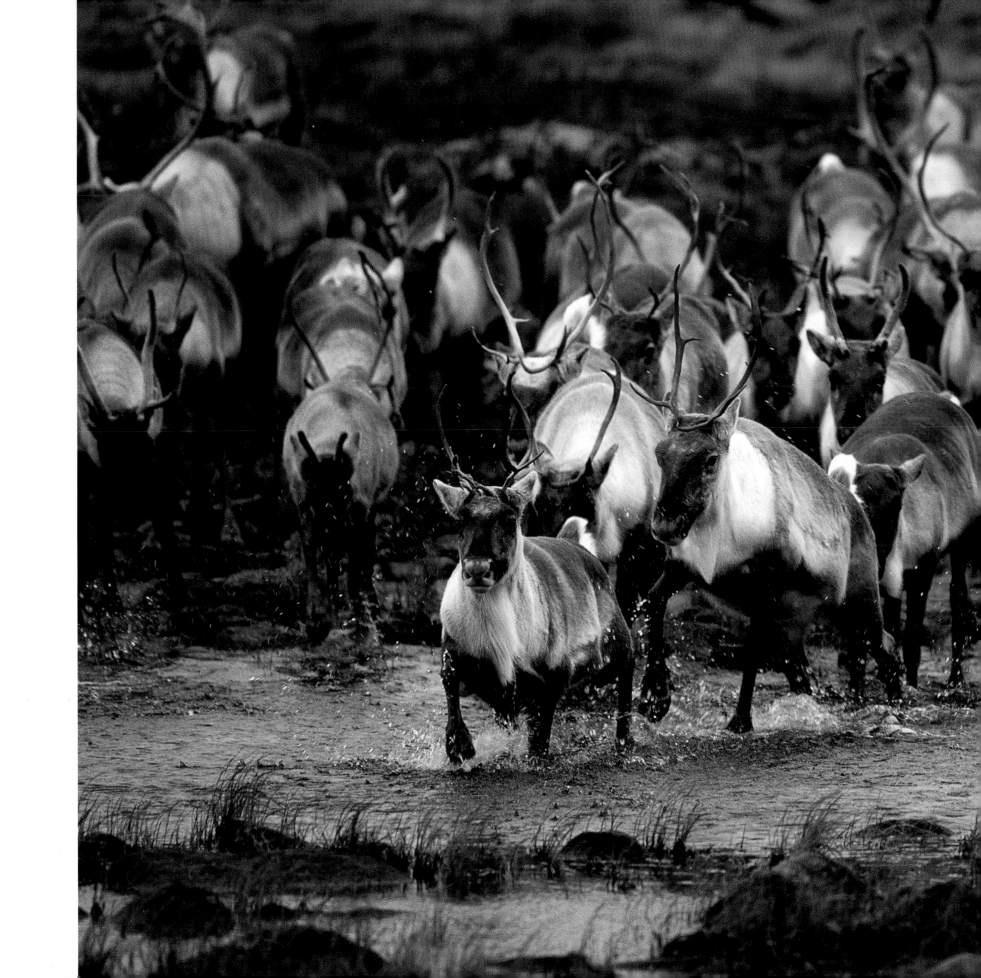

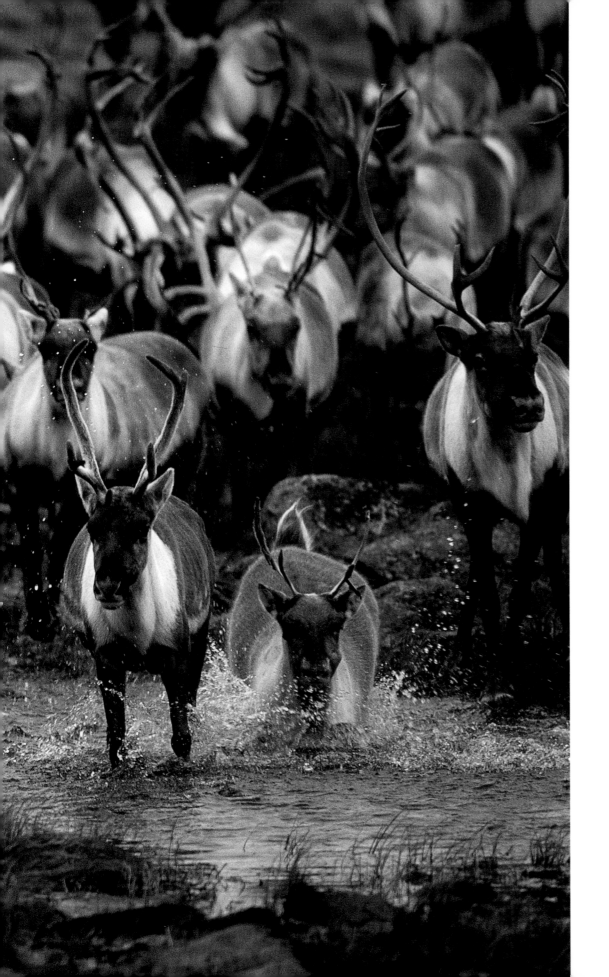

As the weather becomes cooler, the caribou's internal clock drives them hundreds of miles south toward the tree line, where they will seek nutrition for the long, cold winter.

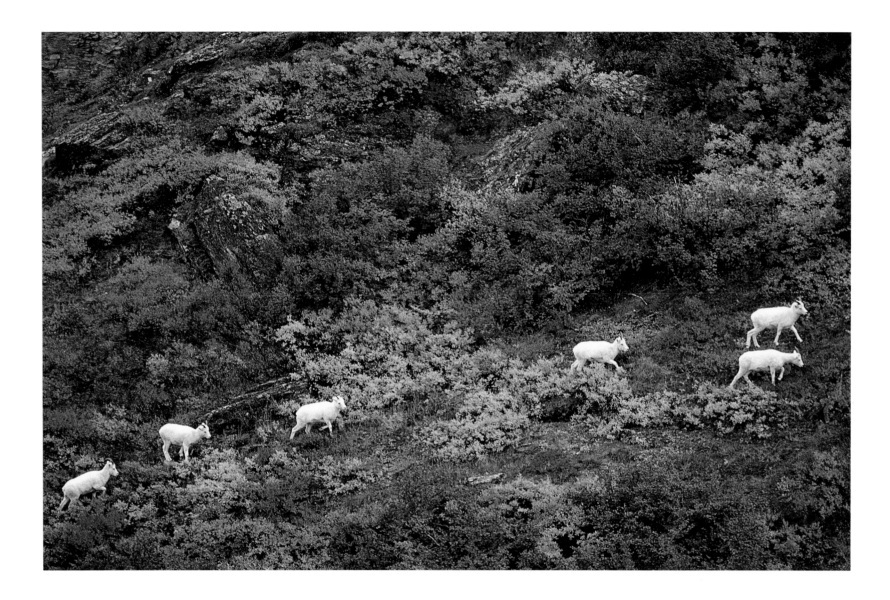

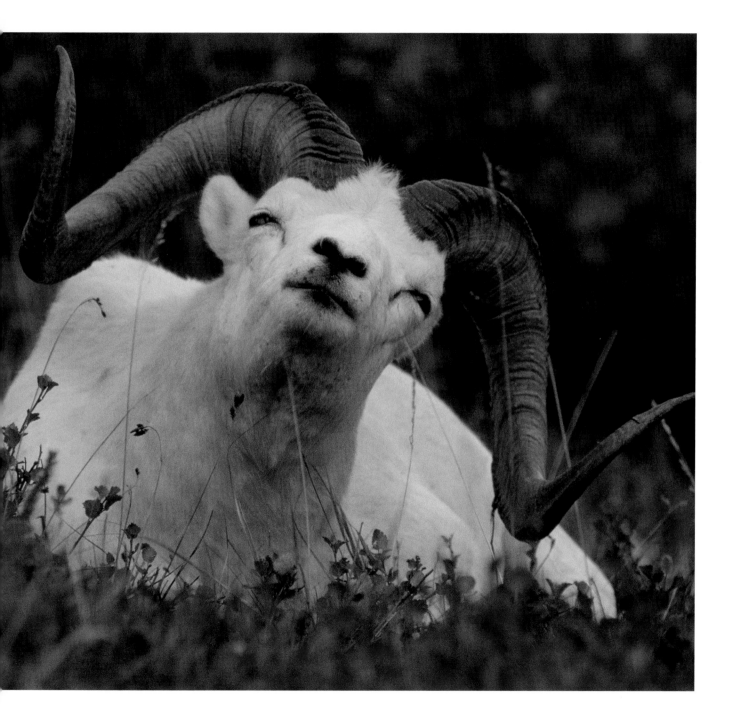

FACING PAGE *Looking like splashes of white paint on a tapestry of red and yellow, Dall's sheep ewes head for higher ground after spending a day feeding at lower elevations.*

LEFT *A quizzical-looking Dall's sheep lies in a field of autumn grasses and willow bushes.*

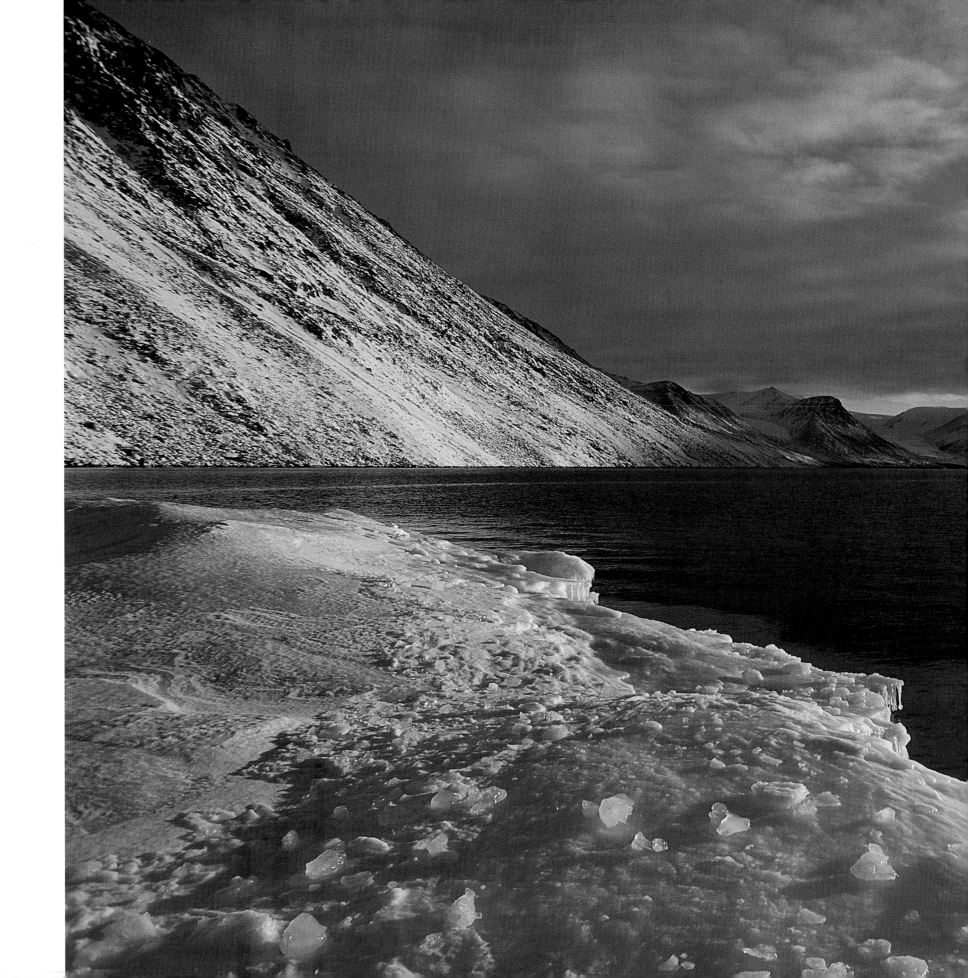

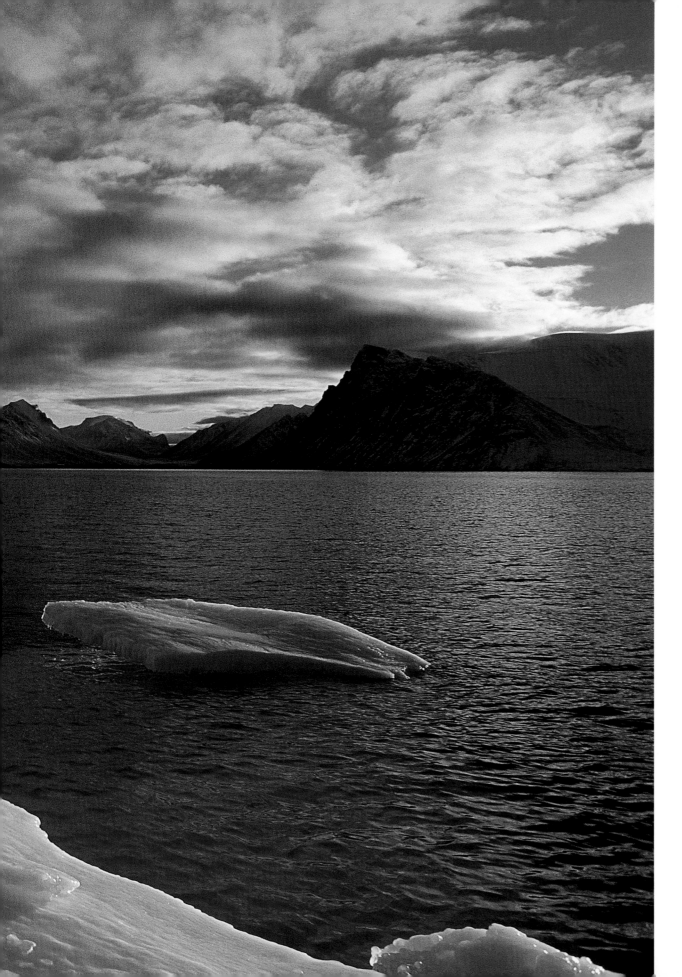

Last light illuminates the ice as an autumn day draws to a close on Baffin Island.

7 1

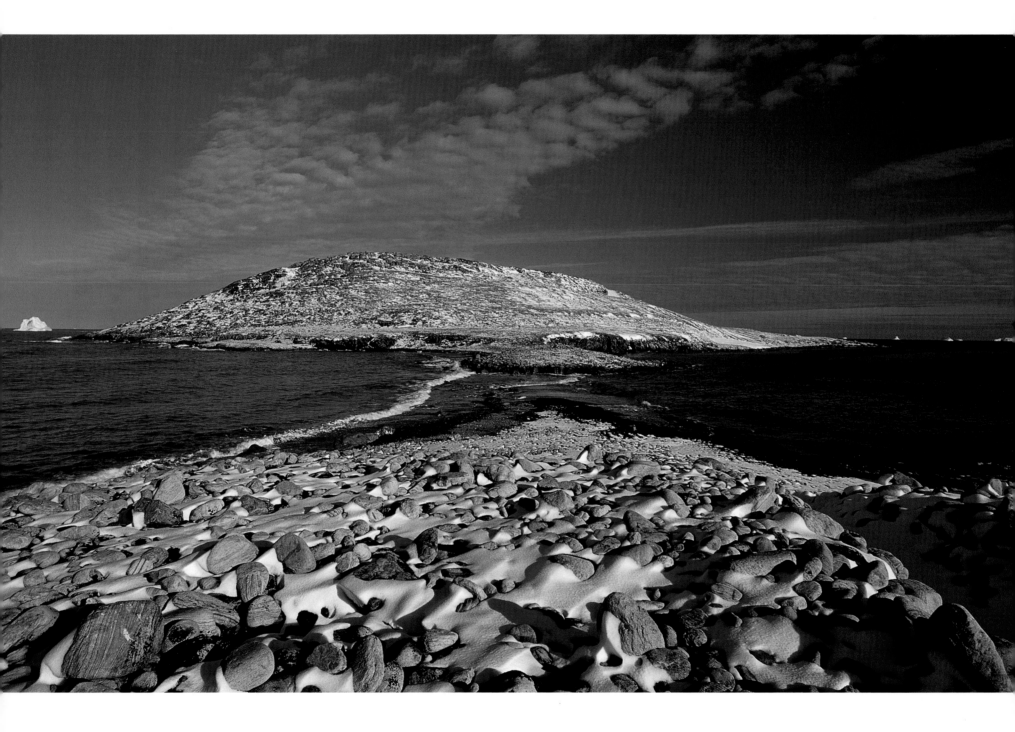

FACING PAGE *Rounded stones cover the shores of eastern Baffin Island. Inuit used the stones to cache their winter meat supply of bowhead whale and other animals. These stones also provide homes for lemmings and weasels.*

ABOVE *An early-morning sunrise paints the sky red.*

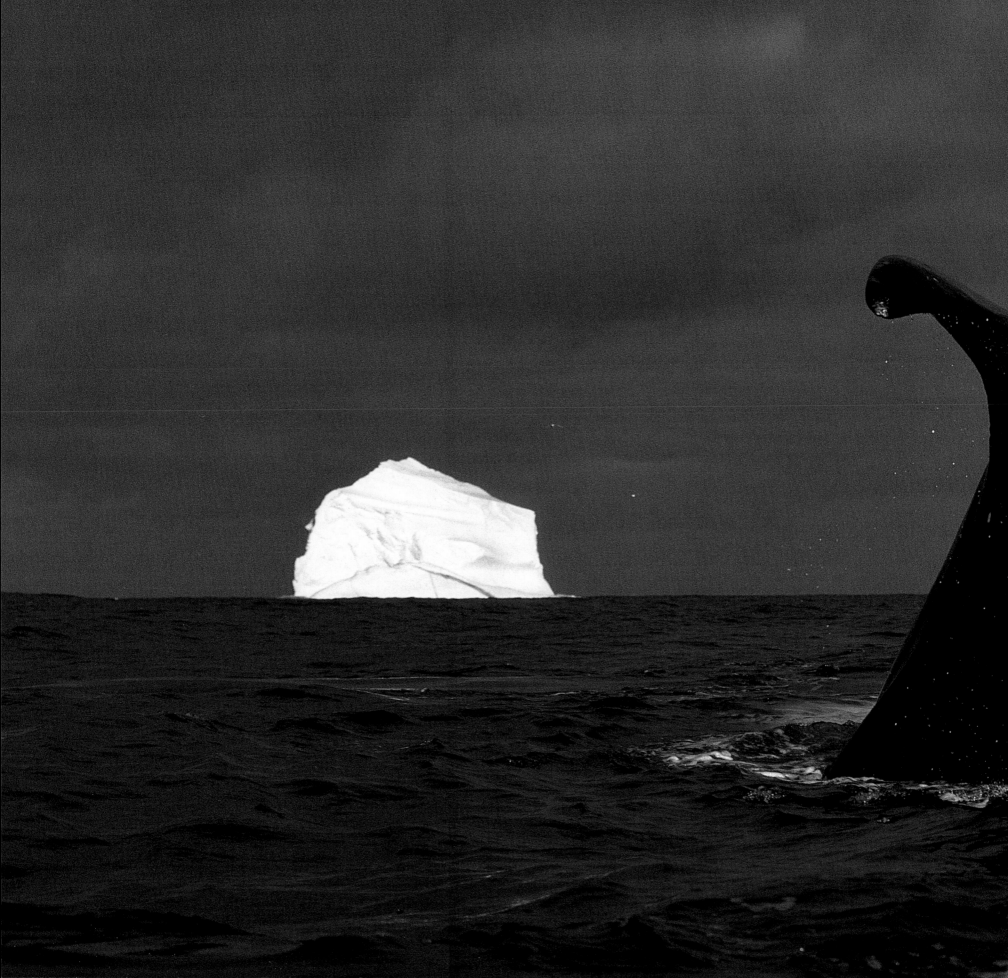

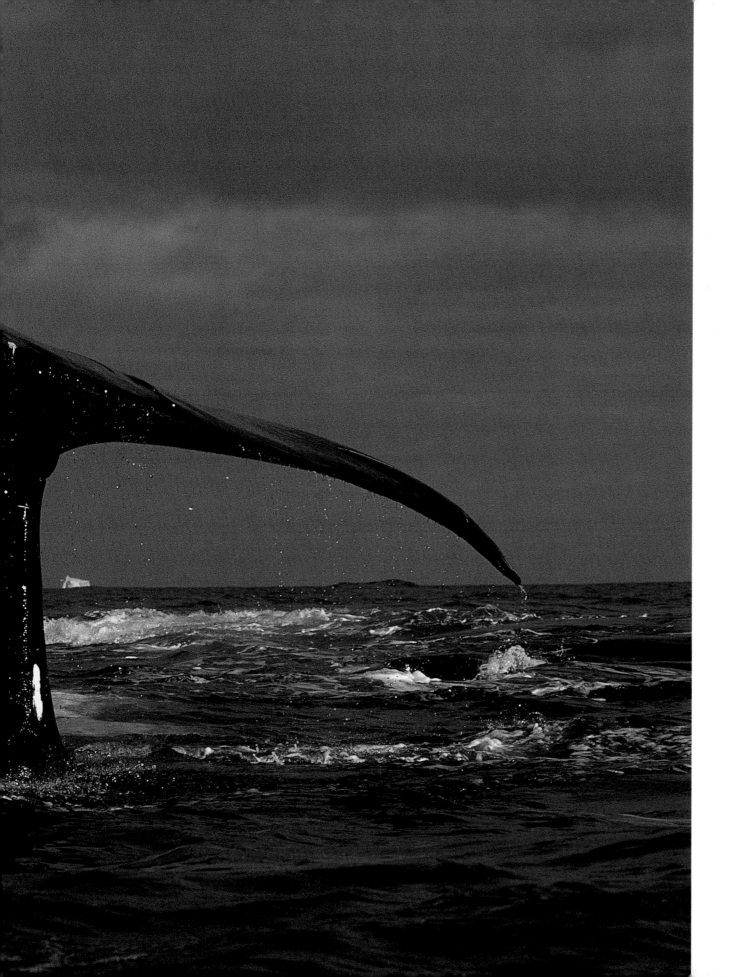

A bowhead whale dives into a trench hundreds of feet below the surface in search of tiny calanus copepods.

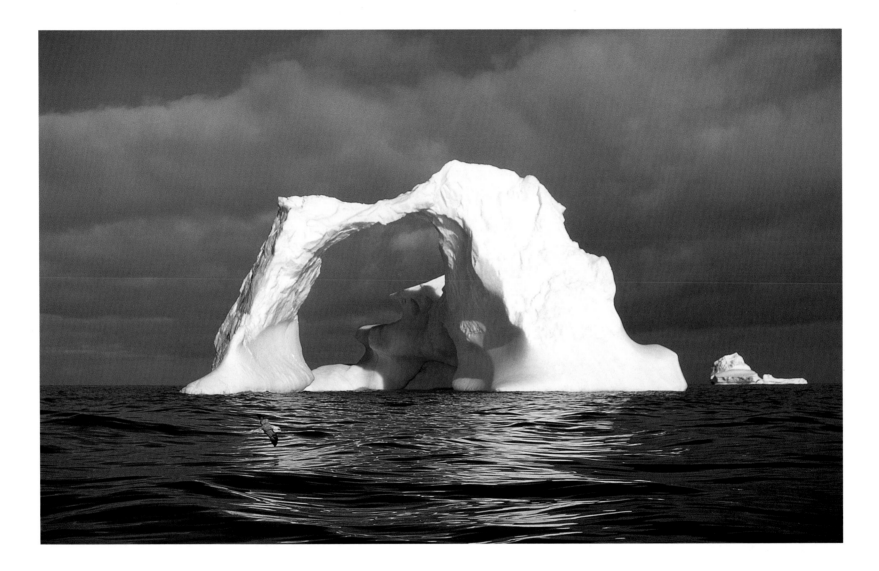

After months of drifting down from Greenland, a massive yet delicate iceberg lodges itself on the shelf of eastern Baffin Island. A low-flying fulmar wind-surfs, just inches above the frigid water, in search of food.

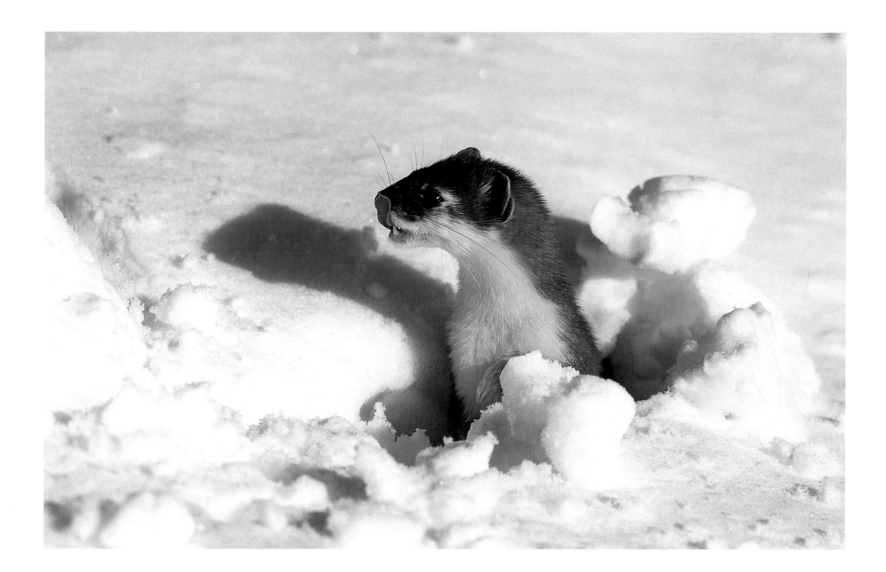

A short-tailed weasel emerges from one of the many tunnel routes it has created to search for lemmings on Baffin Island. Still in its summer colors, this wily predator has been caught off-guard by an early snow.

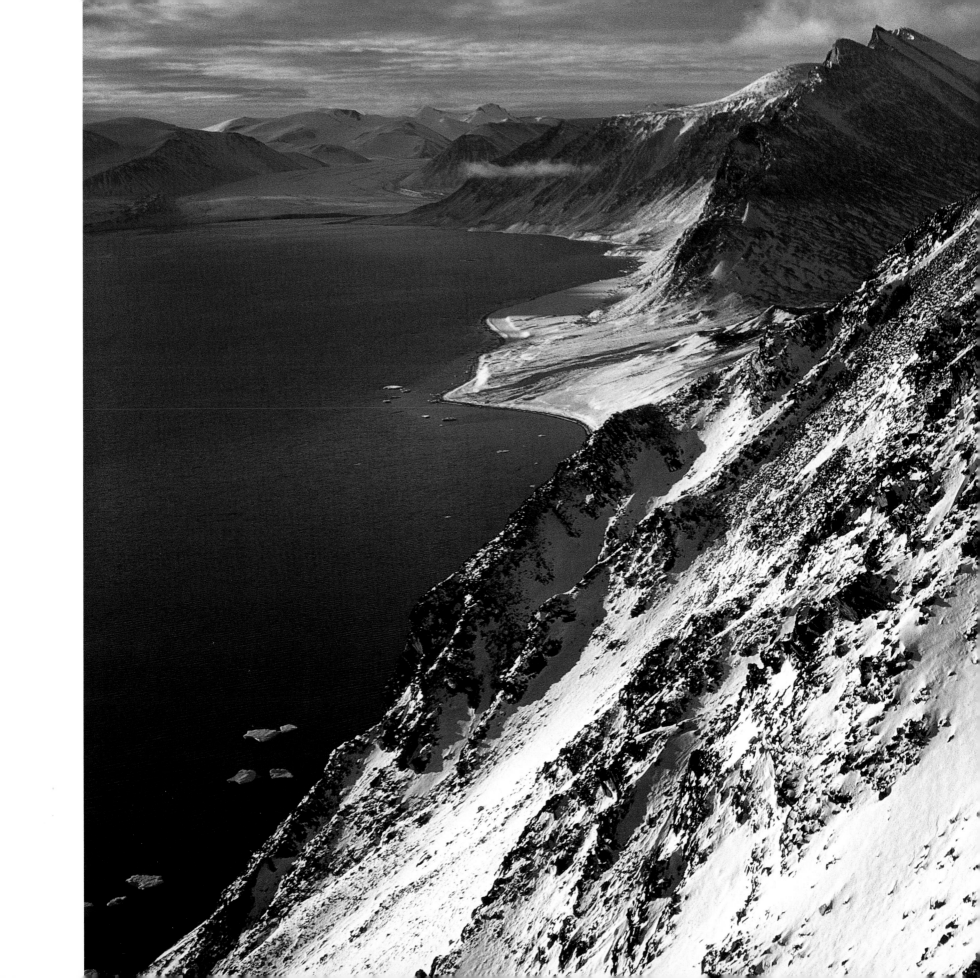

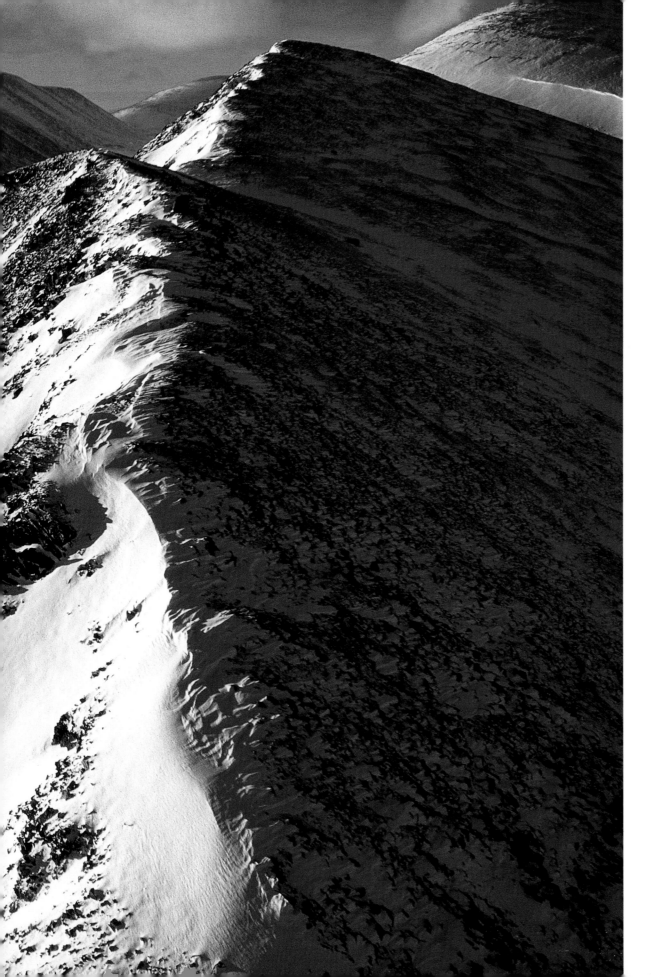

The first snows fall on the shores of Baffin Island.

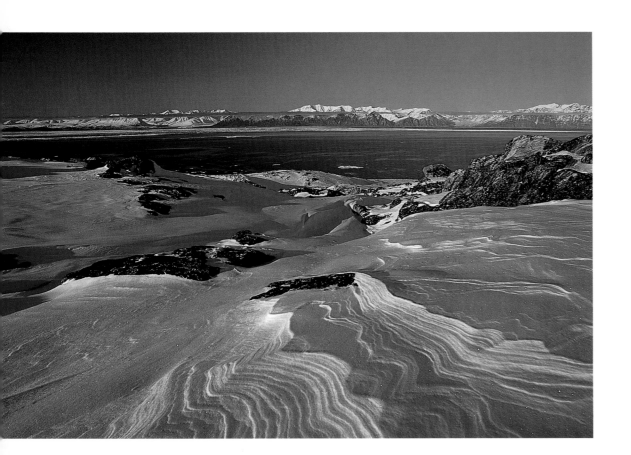

ABOVE *Snow blankets the northern
shores of Baffin Island. Glacier-
capped Bylot Island is visible in the
distance.*

RIGHT *Young male polar bears play
at sparring, possibly to sharpen their
fighting skills, or simply to socialize.*

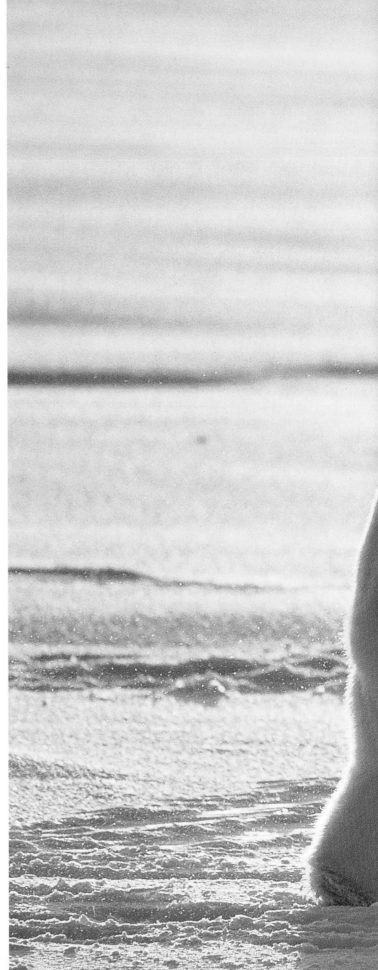

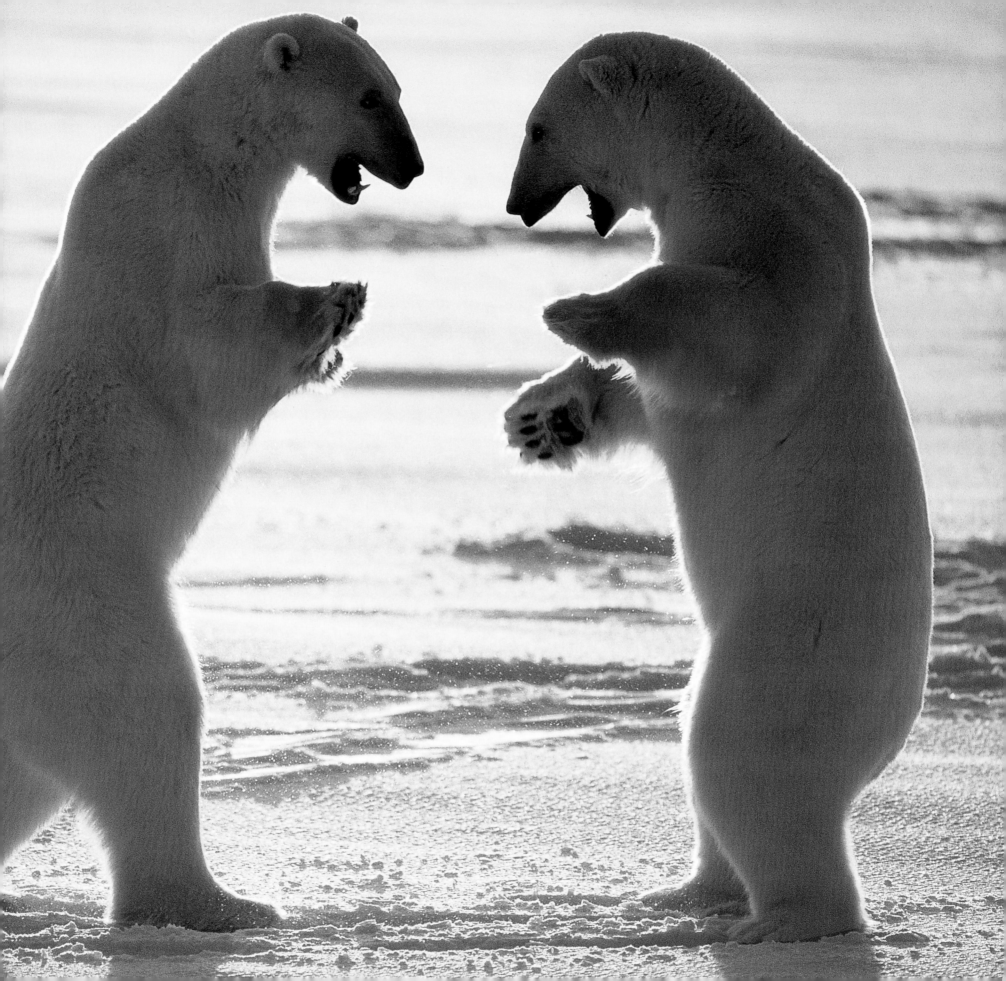

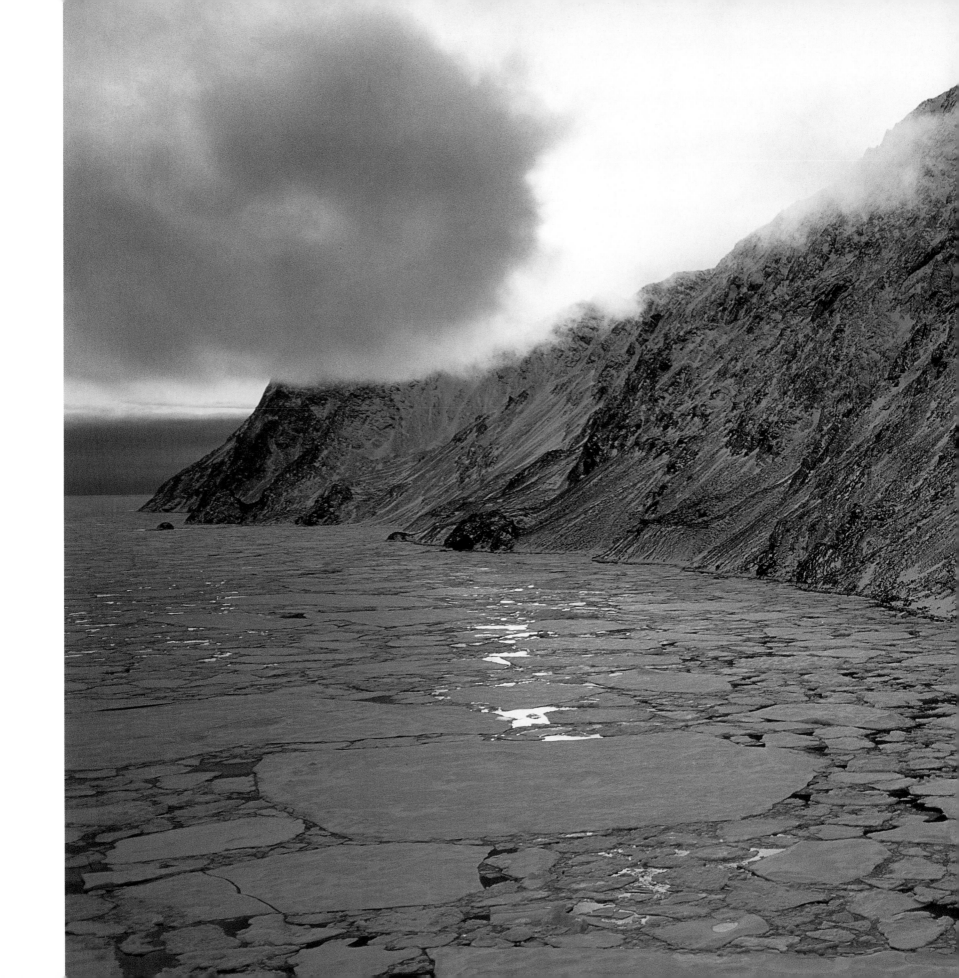

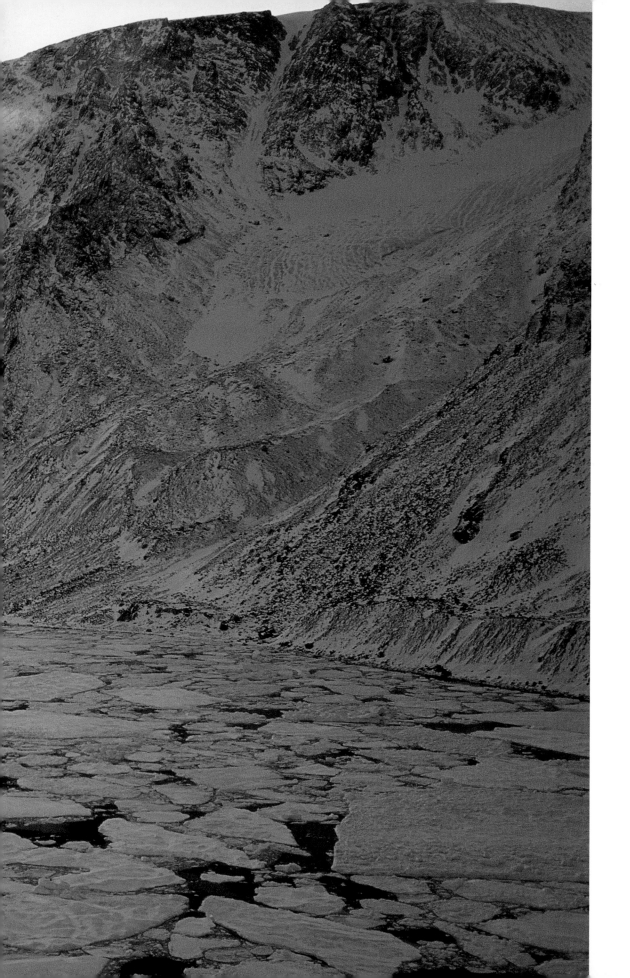

As the sea is about to freeze for another winter, large pans of ice from the previous winter will be frozen along with the newly formed ice.

8 3

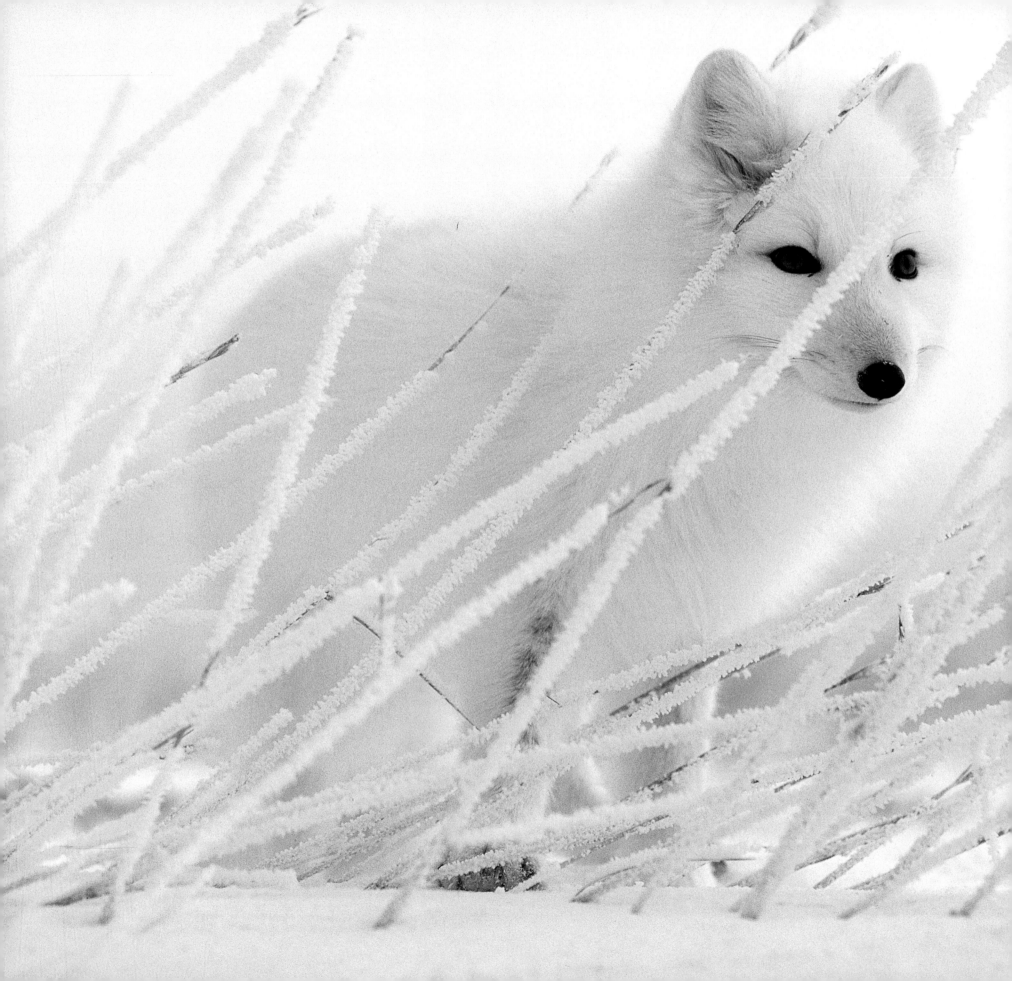

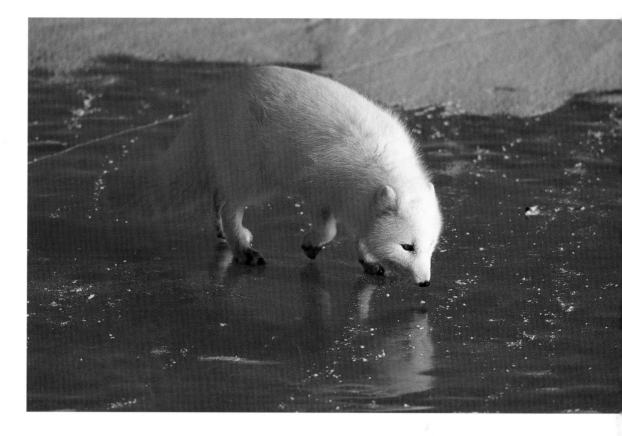

LEFT *After a snowstorm, a
beautiful arctic fox creeps through
frost-encrusted grass, listening for
sounds of lemmings or other rodents.*

ABOVE *An arctic fox makes its way
across a newly frozen pond.*

8 5

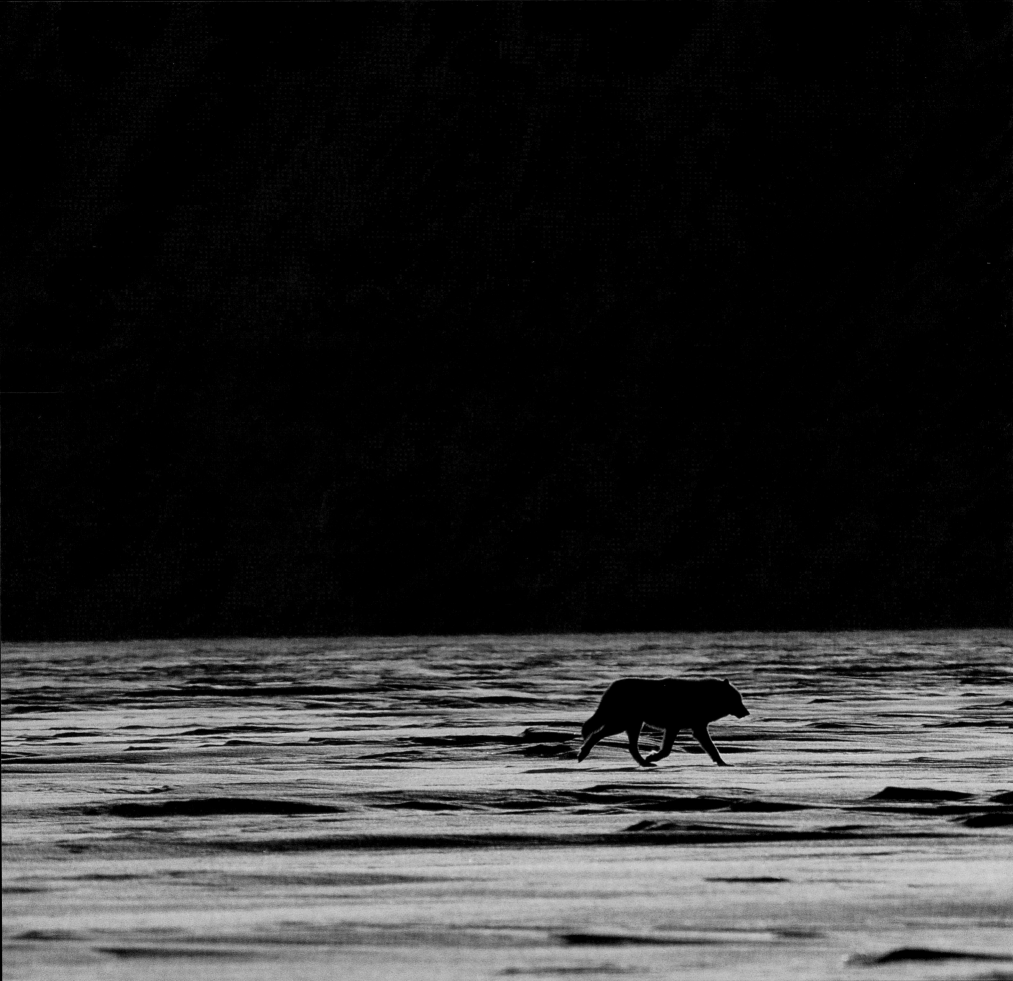

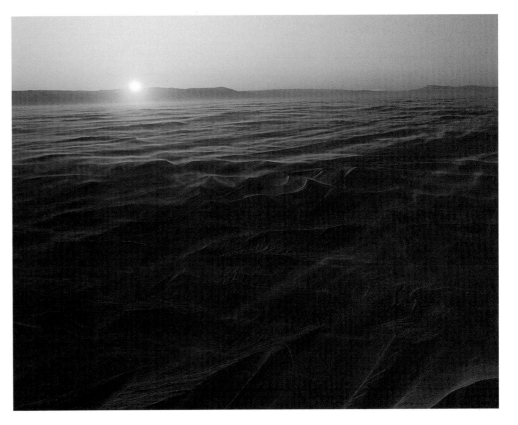

LEFT *A lone arctic wolf lopes along on the sea ice on a late-winter's day.*

ABOVE *The sun sets over an inhospitable winter seascape.*

87

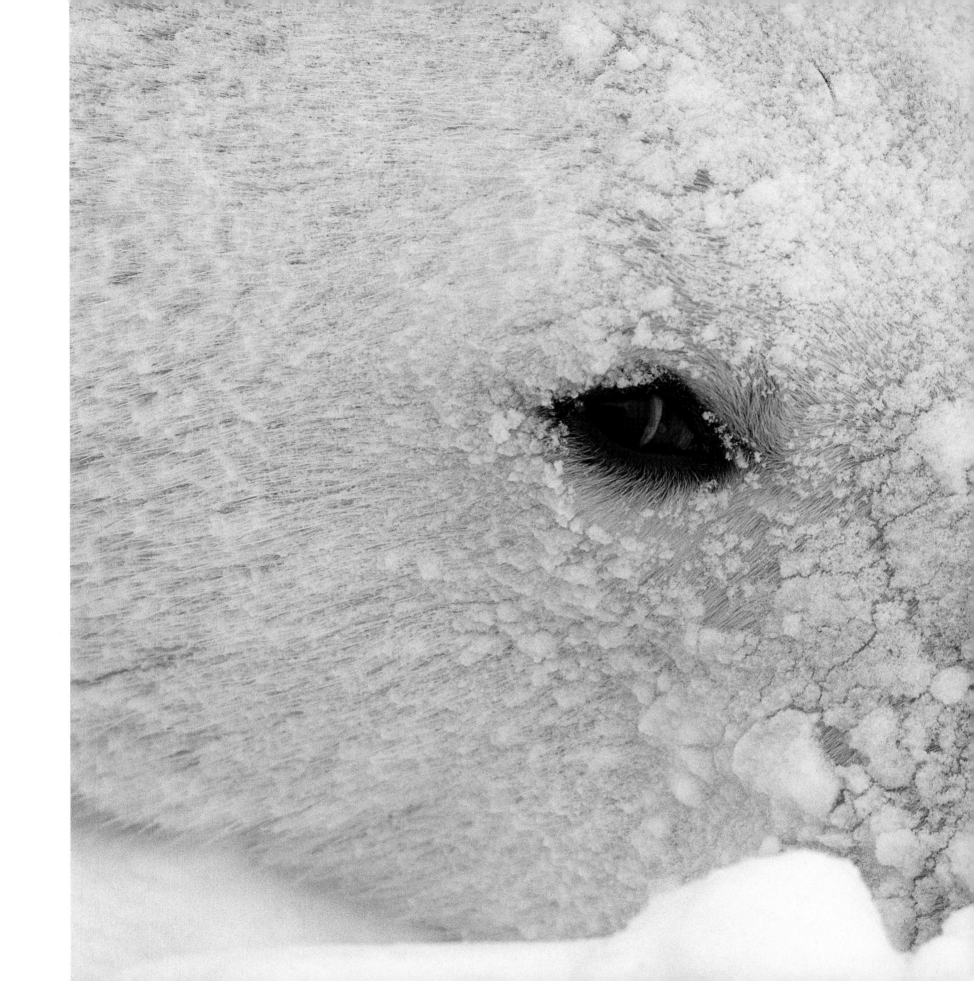

A polar bear patiently waits out a storm, tucking his sensitive nose into a snowbank to keep the wind from blowing snow into his nostrils.

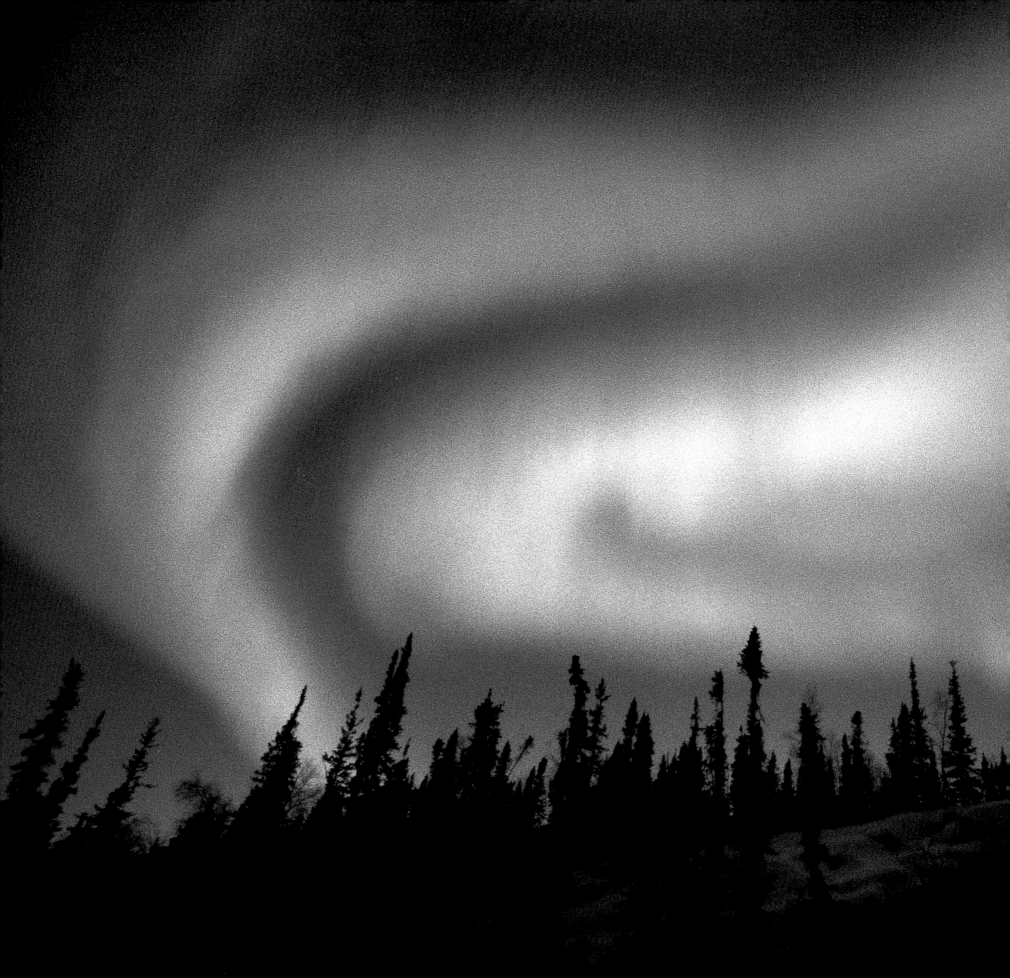

Dazzling green-and-white streamers
of the aurora borealis light up a cold,
dark Arctic night.

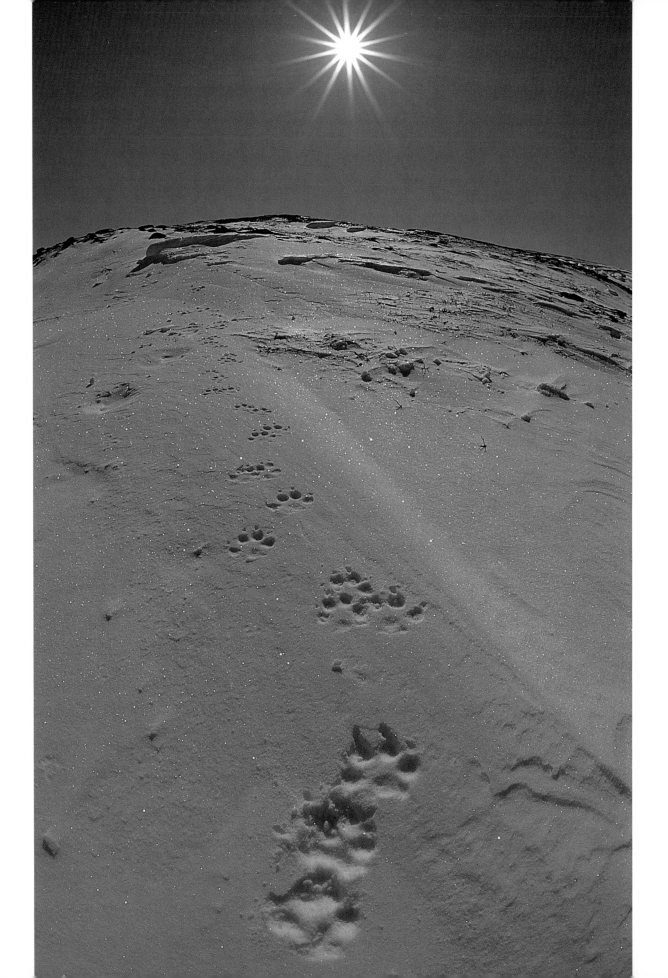

RIGHT *Tracks of the elusive arctic wolf lead up the side of an esker. From here the wolf can spot potential prey or find an easy route for traveling.*

FACING PAGE *This wild lynx is well equipped for winter with its heavy fur coat and large paws, which keep it afloat on deep powder snow.*

9 2

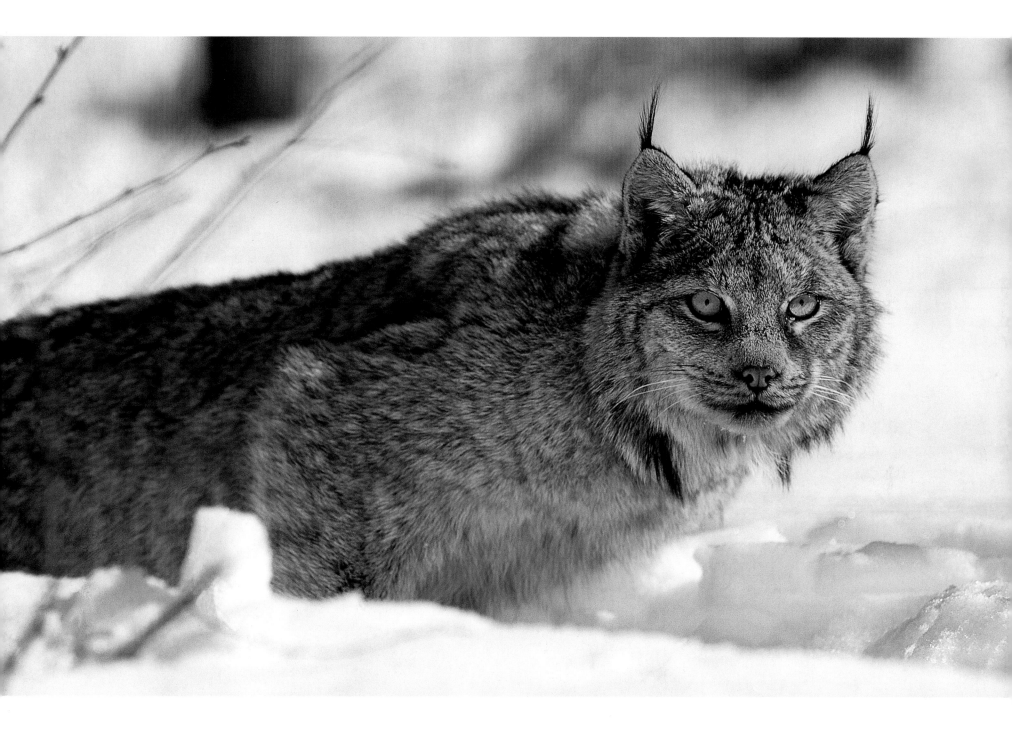

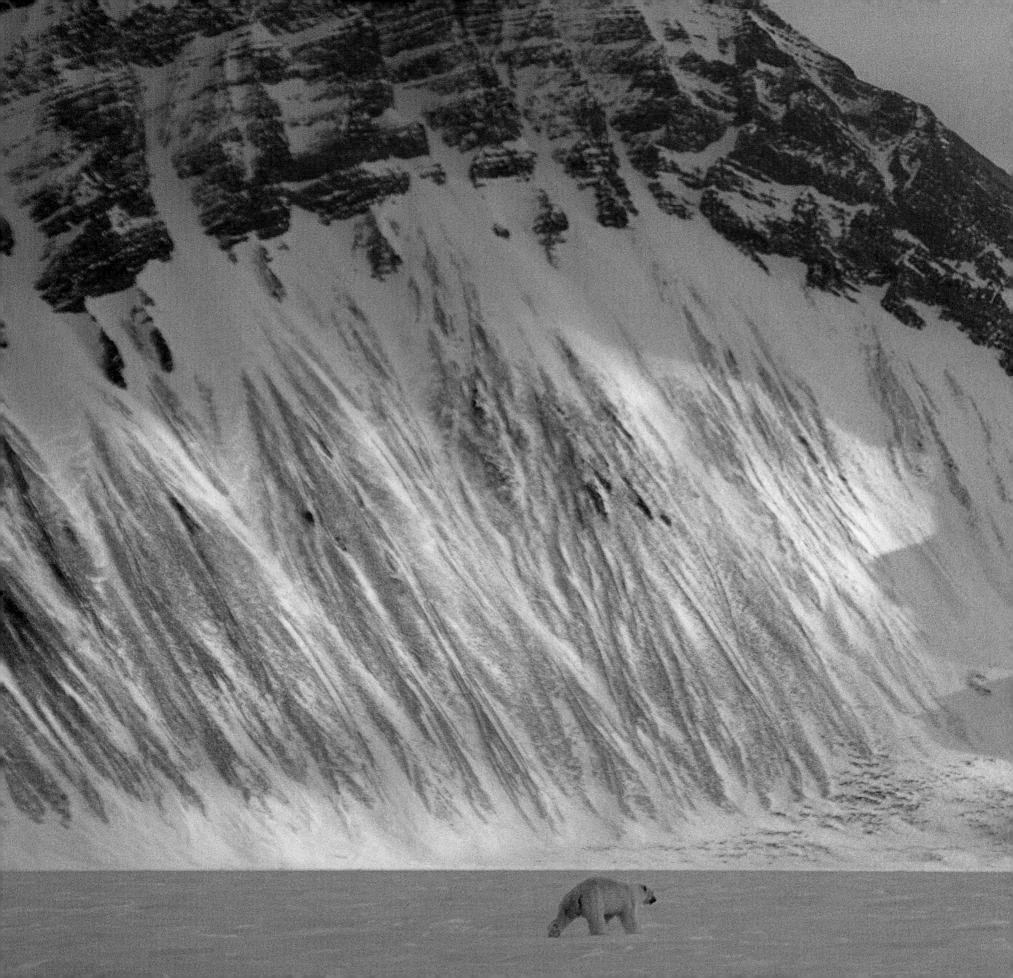

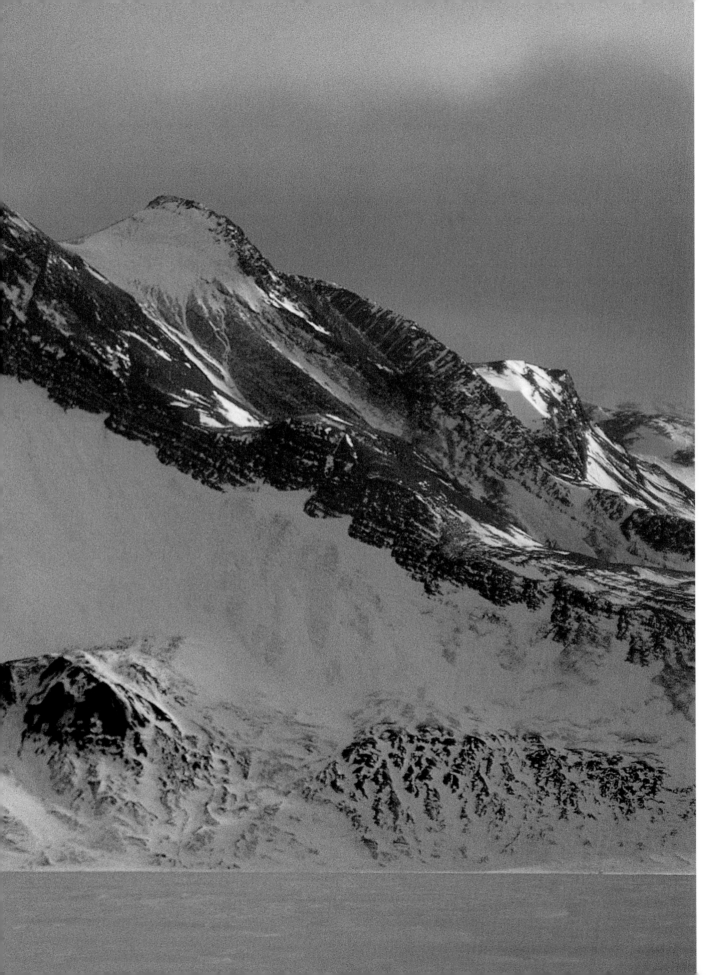

A polar bear roams the sea ice on an Ellesmere Island fjord.

95

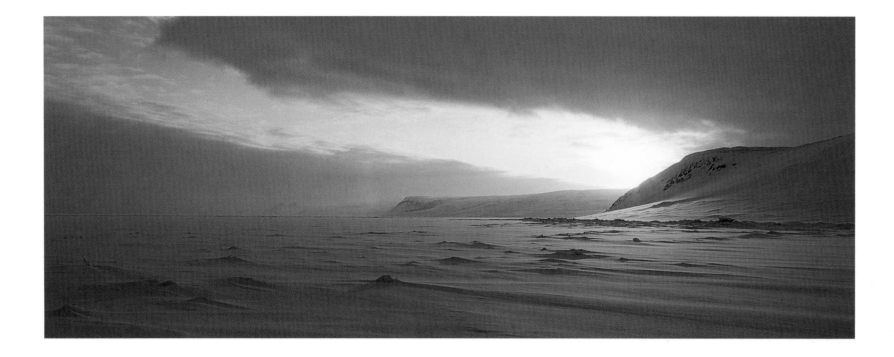

ABOVE *A winter scene on Ellesmere Island.*

RIGHT *In the warm glow of twilight, an arctic hare stops to check its surroundings while grazing on buried lichens.*

FACING PAGE *A willow ptarmigan rests in a snow den shelter during a −40 °F cold snap. Normally, when the snow is deep enough, ptarmigan and grouse bury themselves completely under the snow.*

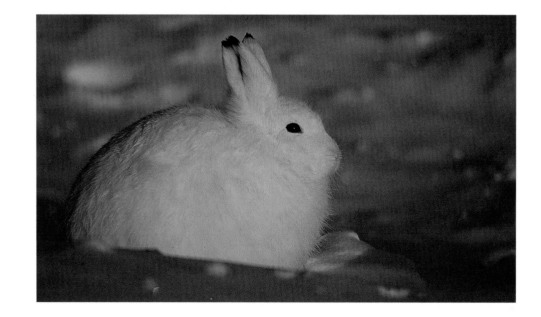

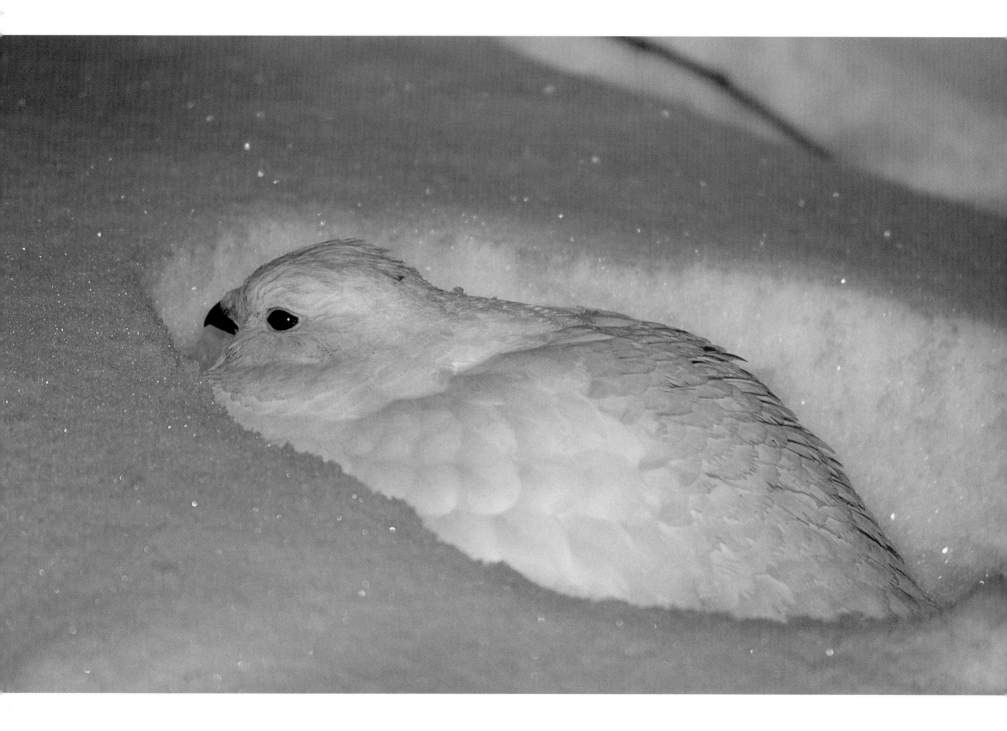

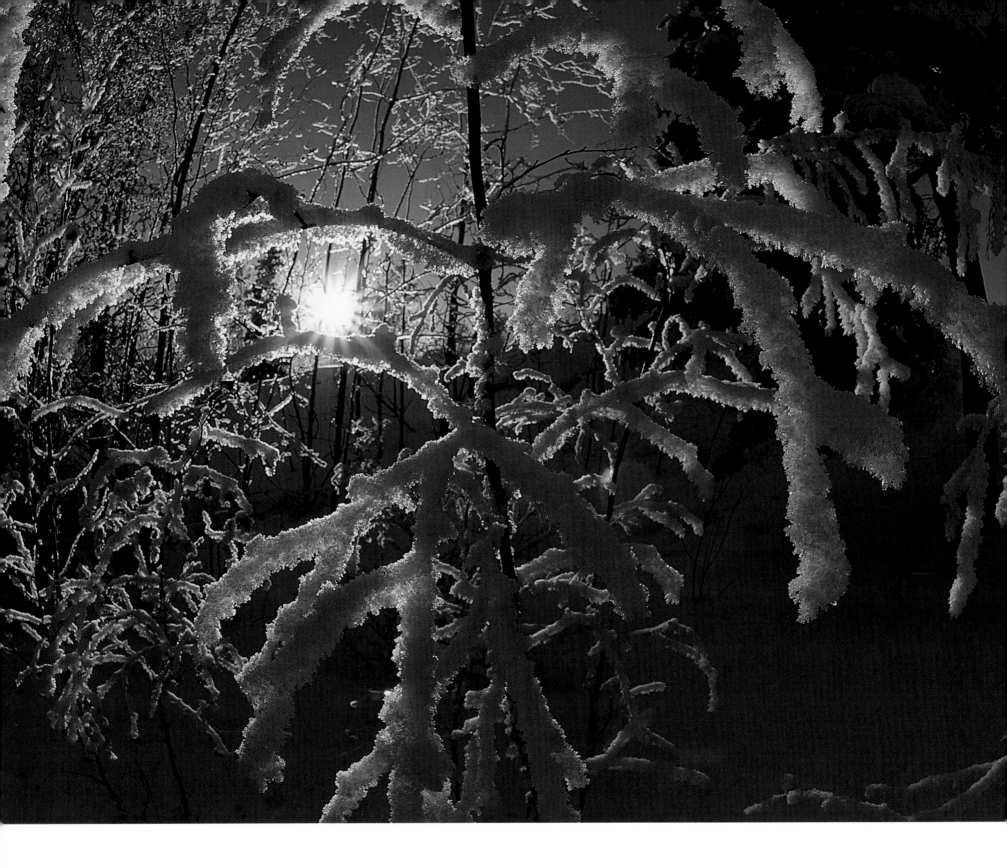

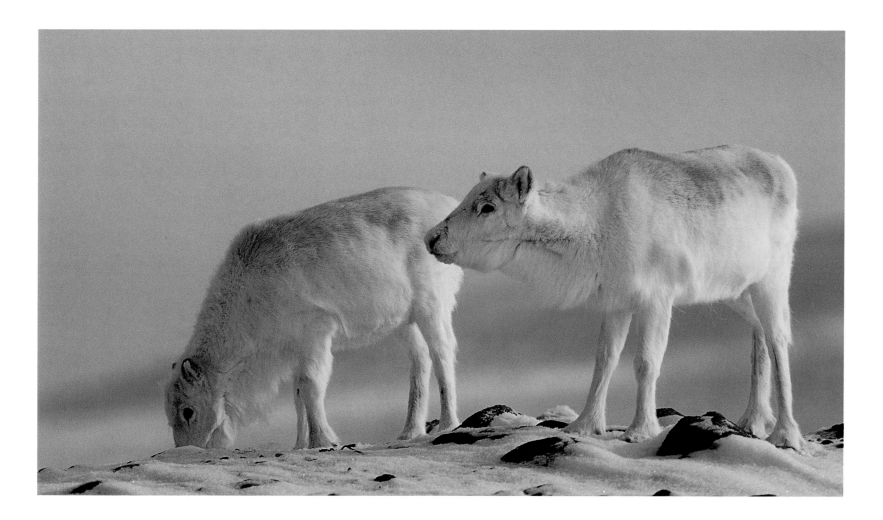

FACING PAGE *When winter conditions permit, ice crystals in the air adhere to every available surface, creating a magical world.*

ABOVE *Peary caribou break through the wind-packed ice and snow to forage for vegetation. Peary caribou have recently suffered a drastic decline in population and may face extinction.*

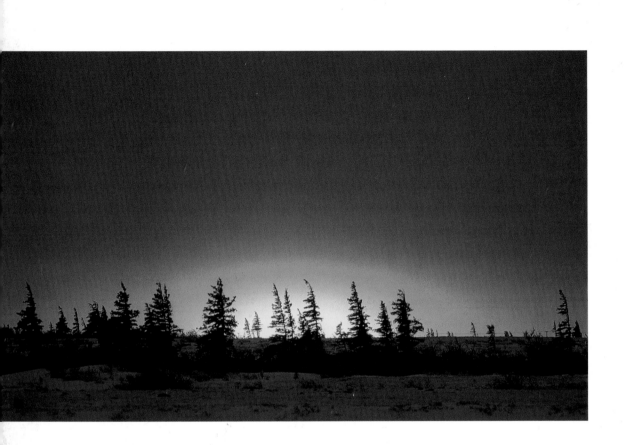

ABOVE *A sunset envelops spruce trees in Churchill.*

RIGHT *A willow ptarmigan lunges into the air from a delicate willow branch.*

OVERLEAF *With only a hint of light still remaining at 3:00 A.M., this polar bear's warm breath collides with the −40 °F air temperature, creating a rosy plume. No other animal is a better symbol of the Arctic and of the strength required to flourish in this cold climate.*

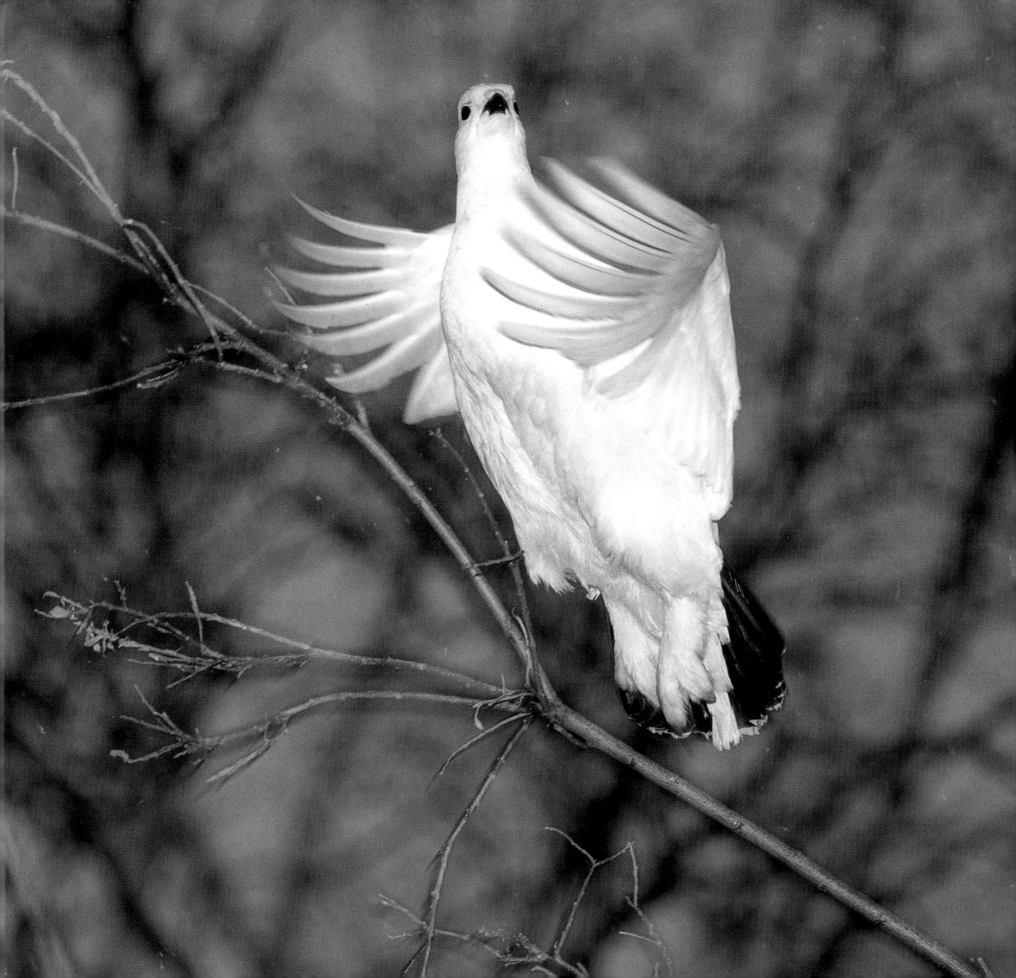

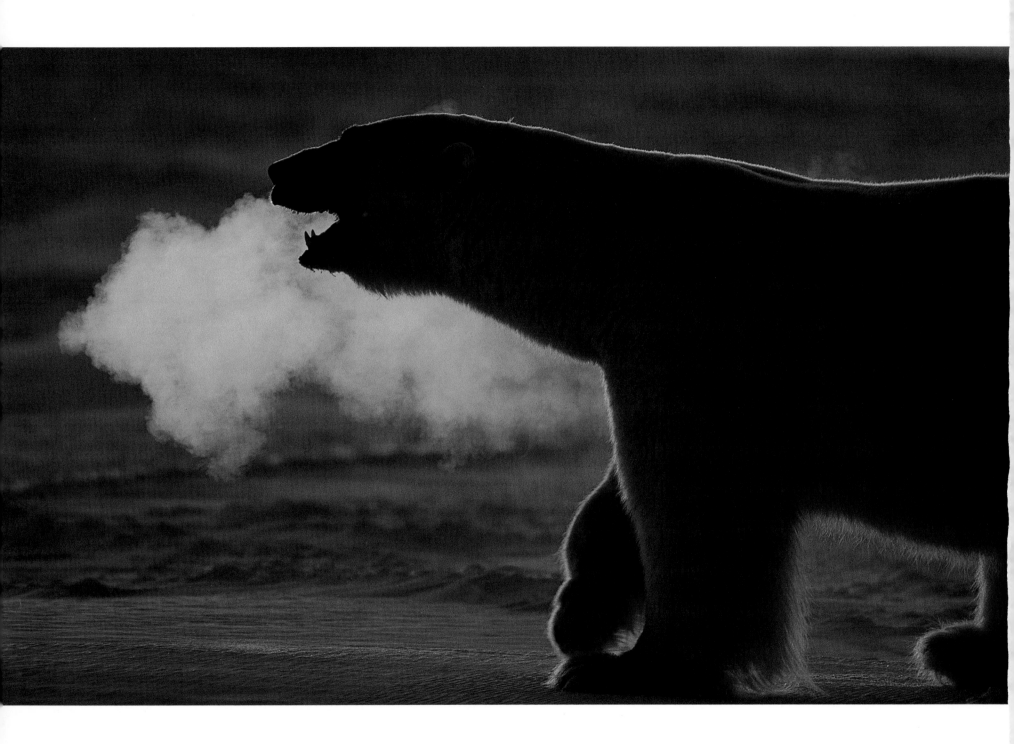